IMAGES
of America

ESSEX
SHIPBUILDING

October 2015

To my Dad,
 I thought this book
might "tweak" your interest
in the maritime.
 With love,
 Michelle

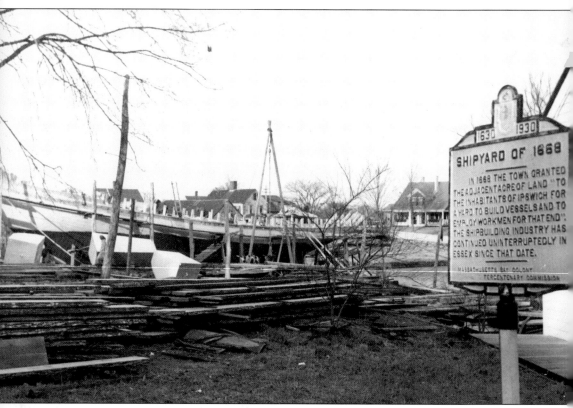

This state historical plaque, seen beside the Story shipyard in 1938, marks the area set aside by the town for shipbuilding in 1668.

IMAGES
of America

ESSEX
SHIPBUILDING

Courtney Ellis Peckham

ARCADIA
PUBLISHING

Published by Arcadia Publishing
Charleston, South Carolina

Printed in the United States of America

Library of Congress Catalog Card Number: 2002108400

For all general information contact Arcadia Publishing at:
Telephone 843-853-2070
Fax 843-853-0044
E-mail sales@arcadiapublishing.com
For customer service and orders:
Toll-Free 1-888-313-2665

Visit us on the Internet at www.arcadiapublishing.com

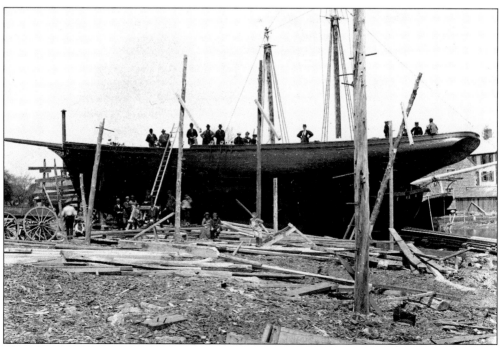

The schooner *E.C. Hussey* nears completion at the A.D. Story shipyard in 1895.

CONTENTS

ACKNOWLEDGMENTS

The production of this book is due entirely to the generosity and knowledge of Dana A. Story, shipbuilder, photographer, historian, and author. After spending decades researching, documenting, and writing about the town of Essex and its shipbuilding history, he recently donated thousands of photographs, papers, and artifacts to the Essex Historical Society and Shipbuilding Museum. He remains the expert in residence, always willing to answer questions and share his experiences. His patience and good humor have made this photographic history a pleasure to compile.

The Essex Shipbuilding Museum's debt to Dana A. Story goes beyond this. Indeed, without his involvement and his passion, the preservation of the unique history of this town would be very much in question. With gratitude from the board of directors and the staff, as well as the many people everywhere who are fascinated by the extraordinary history of this very special place, this book is dedicated to him.

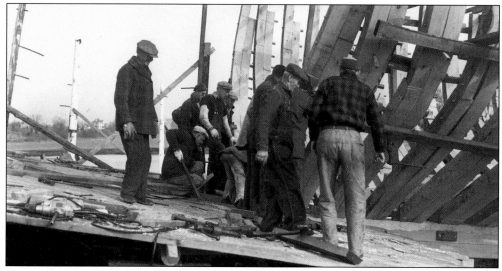

For more than three centuries, the shipbuilders of Essex crafted a tradition whose legacy still endures.

INTRODUCTION

It is hard to imagine another small New England village that can boast a heritage like that of Essex. For centuries, this town supplied the North Atlantic fishing fleets with thousands of the vessels that plied its icy waters for cod, haddock, mackerel, and halibut. It is estimated that 4,000 vessels have headed down the ways and out to sea from this place, a truly remarkable achievement for a town whose population consisted of only 1,500 souls for most of it history.

When the area was settled in 1634 as Chebacco Parish of Ipswich, it was an ideal place for shipbuilding, with a protected estuary leading to the ocean, as well as forests rich with stands of oak and pine. By 1668, shipbuilding was significant enough here that the town of Ipswich set aside an acre of land by the Chebacco River "for the purpose of building vessels and employing workmen to that end."

Early on, shipbuilders were farmers and fishermen as well, engaging in whichever activity best suited the season. They traded in their vessels with ports as far away as the Caribbean. Then, in the 18th century, the Chebacco boat emerged. After the American Revolution, when much of the fishing fleet of New England had been depleted, these vessels gave this place its reputation for building vessels quickly and at a fair price. Payment terms were favorable as well; shipbuilders would often wait until the vessel landed a trip of fish before expecting a final payment.

In the 19th century, Essex gave up its fishing fleet and turned to vessel construction year-round. At the same time, its neighbor Gloucester ascended to the role as the fishing capital of North America. This neighborly relationship served both communities well and, by 1851, there were 15 shipyards in Essex, together turning out more than one vessel per week. As technology improved for preserving, packaging, transporting, and marketing fish, Essex schooners grew larger and faster. Swift and graceful, they captured the essence of the age of sail and spread the reputation of Essex shipbuilders around the world.

By 1949, the shipbuilding industry in Essex had vanished, a victim of American progress. An enterprise that had spanned three centuries disappeared with hardly a trace. Shipyards had been but a plot of land near the river; no old factory buildings stood empty, and no abandoned equipment lingered silently to tell its story. Also, few records existed from the shipbuilding industry. For the most part, such records were simply not kept. Fortunately, an extraordinary photographic record of Essex shipbuilding remained to help tell the tale.

This book features photographs selected from the Dana A. Story Collection at the Essex Historical Society and Shipbuilding Museum (exceptions are noted). The collection is the finest of its kind; there is no better documentation of the building of wooden fishing schooners,

and the Essex Shipbuilding Museum is proud and honored to be its custodian. The collection helps illustrate that the little village of Essex indeed played a massive role in American maritime history.

Photographs can tell the story only from the late 19th century forward. Because of this, these images deal mainly with the shipyards of the Story and James families. Before them were dozens of others, particularly from the Burnham family, whose work preceded photography. For that reason, this volume cannot be considered a complete representation of Essex shipbuilding, but it does provide a glimpse at a small part of a very big story.

It is hoped that these photographs will leave people with an understanding of the scale and the scope of the Essex shipbuilding tradition—the shipyards, the workers, the customers, and the vessels—that made this place the foremost producer of fishing schooners in the heyday of the North Atlantic fisheries.

—Courtney Ellis Peckham
Essex Historical Society and Shipbuilding Museum

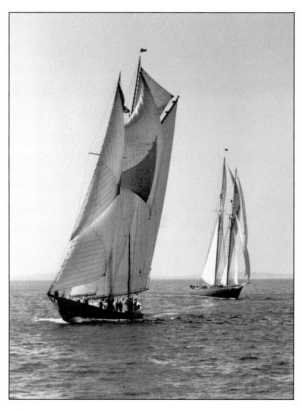

Elegant under full sail, Essex-built schooners were the pride of the North Atlantic.

One

THE SHIPBUILDING
TOWN

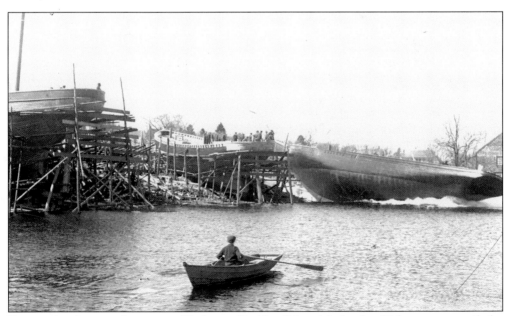

From its earliest settlement as Chebacco Parish of Ipswich in the 17th century until the mid-20th century, shipbuilding dominated the landscape and the culture of Essex. The Essex shipbuilding industry left an unusual legacy in this otherwise typical New England town.

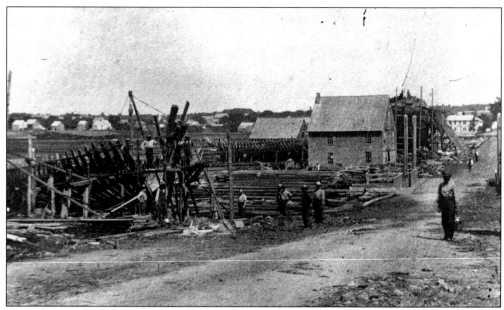

The middle of town, curled around the Essex River basin, was the center of shipbuilding activity. This photograph, taken in 1872, is the earliest known picture of the Essex causeway. The shipyard of Joseph Story is close at the left, and the yard of James & Mackenzie is visible farther down the road.

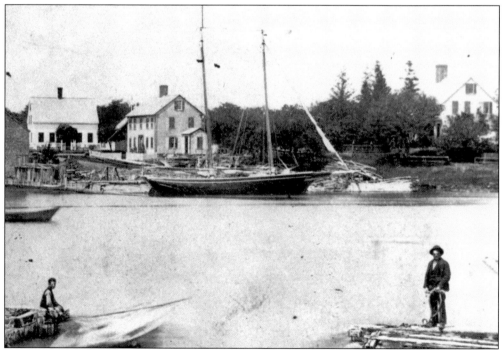

In its early days, Essex vessels were rigged by their builders and fitted out for fishing. This schooner looks to be recently launched from the Oliver Burnham shipyard (now the yard of H.A. Burnham) in the late 1860s or early 1870s. The men in the foreground are standing on the tidal gates that helped control the flow to the sawmill, which was installed in 1822.

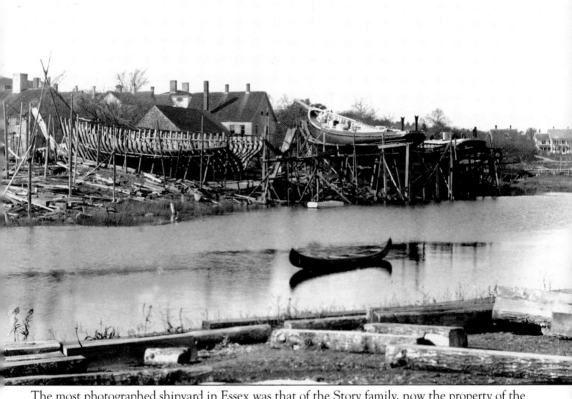

The most photographed shipyard in Essex was that of the Story family, now the property of the Essex Shipbuilding Museum. The Congregational church steeple is at the far left. In the foreground at the left is the site of the old Story homestead, where the museum store and office are now located. In this 1904 photograph of the Arthur D. Story yard, the schooner *Fannie E. Prescott* is almost ready to launch. An unidentified vessel is in frame at the left, and the schooner *Patrician* is beyond to the right. The Story yard was also the most prolific shipyard in town. During the 19th and 20th centuries, the Story yard supplied Gloucester's North Atlantic fishing fleet with many of its famous schooners.

Arthur D. Story was born on October 11, 1854, to a family that had already been building vessels for generations. After attending Phillips Academy at Andover, he started a shipbuilding business at age 18 with Moses Adams. The partnership soon dissolved, but A.D. Story went on to build more vessels than any other individual shipbuilder in the history of Essex. Here, he stands below the bow of the *Columbia* in 1923.

On the far left, Jimmie, the Story shipyard horse, takes a break from his job hauling timber around the yard. Behind the horse is Story's old steam-operated band sawmill, where the structural timbers were sawed out.

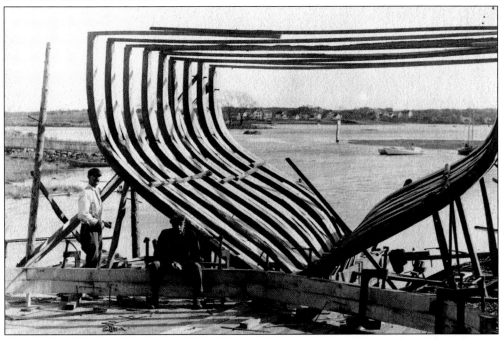

Two unidentified workers at the A.D. Story yard pause for a photographer. The schooner *Angeline C. Nunan* is in the framing stage. This photograph gives a view of typical Essex construction—double-sawn oak frames fastened by wooden pegs known as trunnels (treenails). One man sits on the next frame to be raised into place.

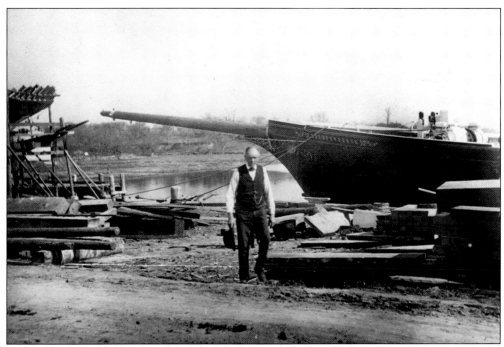

Shipbuilder John F. James walks near the bow of the recently launched schooner *Independence* in 1901. The James family was another of the great Essex shipbuilding families of the 19th and 20th centuries.

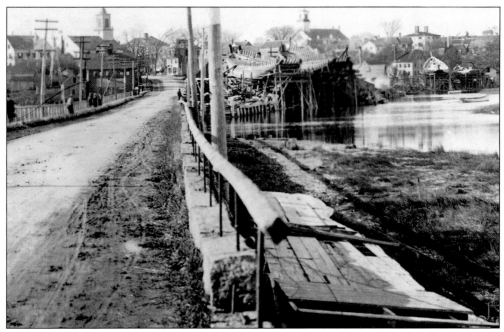

This *c.* 1900 view up the causeway toward the center of Essex reveals three vessels under construction at the James & Tarr yard. Two are visible at the A.D. Story yard.

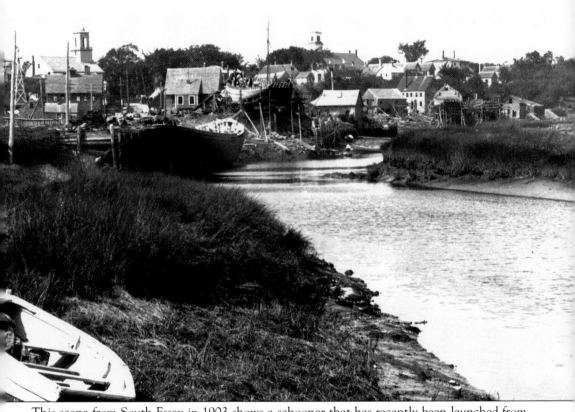

This scene from South Essex in 1903 shows a schooner that has recently been launched from the James & Tarr yard. A clammer's dory can be seen in the foreground. Clamming has been part of the Essex economy since the town's founding, although until the 20th century, clams were used mainly as bait.

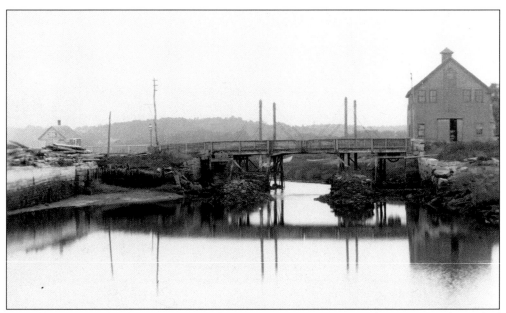

The old Essex drawbridge was built on the long causeway in 1824. The area near the end of landing road on the far side of the causeway had been used as a place for launching vessels since the beginning of Essex shipbuilding. In addition, the shipyard of Moses Adams operated there until 1894—hence, the need for a bridge that could be raised and lowered. The wooden draw was hand operated with chains and windlasses.

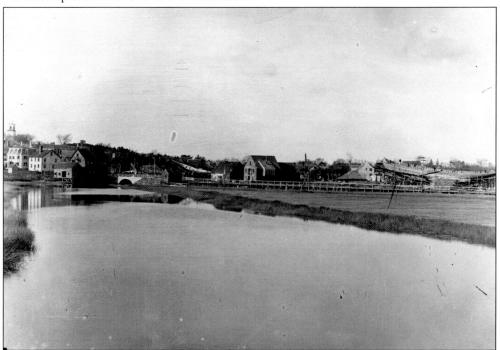

Both the James and Story yards are visible in this view from up the river. The new arched bridge is in place, indicating that this photograph was taken after 1901, when Essex County took over the causeway and installed a new stationary bridge.

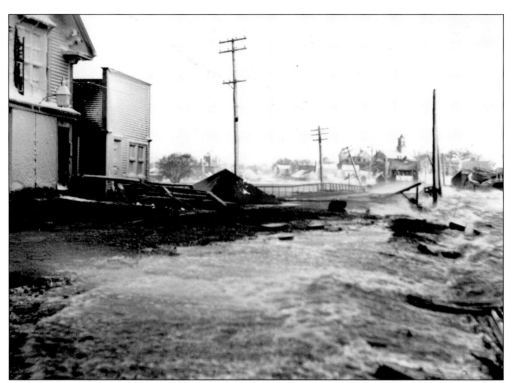

The infamous Portland Gale of November 1898 wiped several buildings and businesses off the causeway. Named for the steamer *Portland*, which was lost during the blizzard en route from Boston to Portland, this storm was one of the worst maritime tragedies in modern history.

During the storm, this small sloop was driven ashore and up into the yard of this South Essex home. The devastation in Essex, given the town's fairly sheltered location, offers some idea of the extent of the damage to fishing fleets and the more exposed communities on the coast.

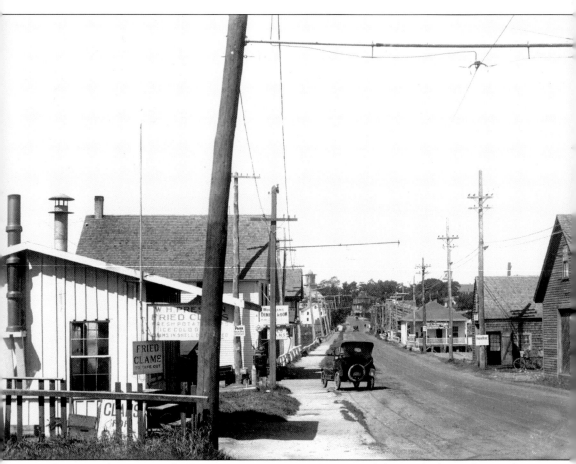

Times are changing on the Essex causeway in 1922. An automobile is parked outside Woodman's Dining Room, now a famous local landmark. Two other fried clam enterprises have also begun, indicating the direction of the town's future economy. The James yard is visible down the causeway at the right.

By the mid-19th century, local sources of shipbuilding timber had been exhausted. The Essex Branch of the Eastern Railroad was established in 1872 and allowed timber and lumber to be carried in by rail from many different parts of the country.

Teamster Arthur Norton used oxen to haul timber from the railroad depot behind the town hall to the shipyards. In earlier days, these deliveries would have arrived via the river on a coasting schooner.

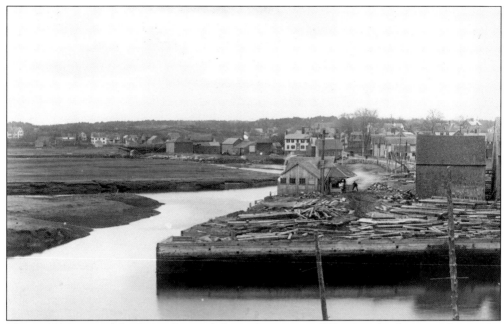

This c. 1904 view of the James shipyard shows Corporation Wharf in the foreground, now the site of Pike's Marina. The Essex Mill Corporation was established here in 1822 to build and maintain a dam, a sawmill, and a gristmill. The South Essex shipyard of Oxner & Story can be seen in the distance, approximately where the Essex River Motel stands today.

Edwin H. Oxner was a Lunenburg, Nova Scotia native who came to East Boston in 1890 to work in the shipyards there. He became familiar with Essex while working as a subcontractor hired to build a three-master in the A.D Story yard. He then became a foreman for A.D. Story until went into business with Lyndon Story in 1901.

Lyndon J. Story was the brother of Arthur D. Story. Oxner & Story operated the South Essex yards that had been used by generations of Burnhams. His partnership with Edwin Oxner dissolved in 1907, but he went on to be a successful merchant tailor. (E.J. Story photograph.)

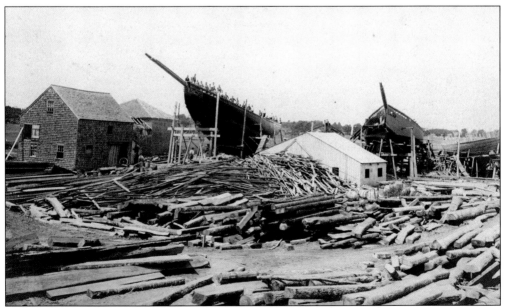

While the Oxner & Story yard was in operation, it produced 51 vessels. The partnership was inspired by a spike in demand for vessels in the early 20th century. During the years 1901 to 1906, the three Essex yards in operation turned out 160 vessels.

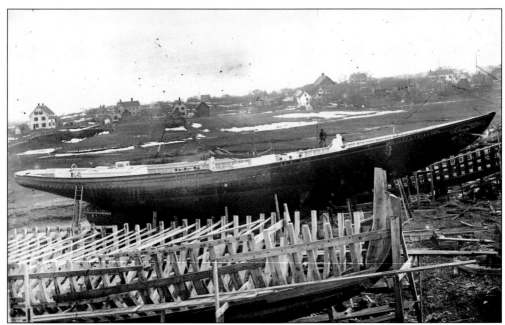

The schooner *Helen B. Thomas*, built at the Oxner & Story yard in 1902, was the first knockabout schooner ever launched. The knockabout design was a safety innovation by naval architect Thomas F. McManus. He wanted to eliminate the bowsprit—or widowmaker, as it was commonly known—so that the headsails could be handled from the deck.

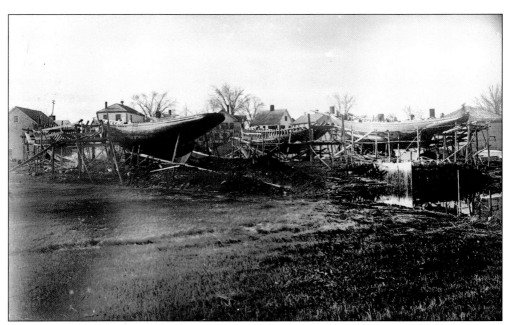

The *Helen B. Thomas* is ready to launch, and the *Robert and Arthur* is next. The *Robert and Arthur* was a 95-foot schooner designed by B.B. Crowninshield and built for the Boston fisheries.

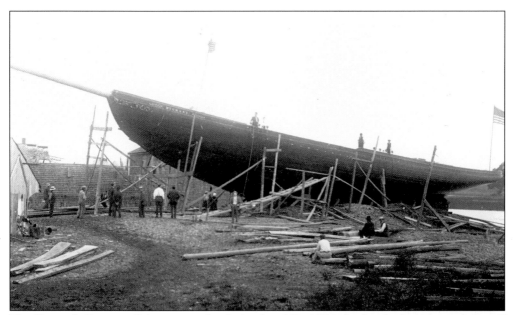

The Oxner & Story yard's history was bright but brief. By 1906, the firm had overextended itself and folded. The schooner *Richard*, built on speculation, sat on the ways for a year before it was sold at auction to a Gloucester sailmaker. The vessel was so dry that the old Essex handtub had to pump the vessel full of water to swell its planking.

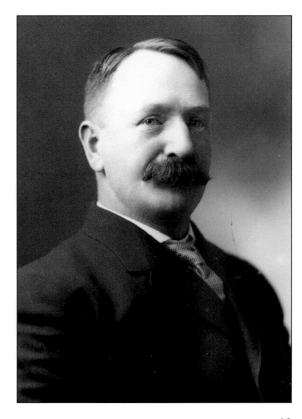

Leonard B. McKenzie was an Essex native who first built vessels at Pavilion Beach in Gloucester. He established a shipbuilding business in the same South Essex yard from 1912 to 1913, turning out three schooners. His father, also Leonard McKenzie, had been a partner of John James from 1852 to 1874.

Owen Lantz also operated a yard in the South Essex location from 1916 to 1920. He was a Mahone Bay, Nova Scotia native who worked in the Essex yards and then built vessels in Gloucester before opening his business in Essex.

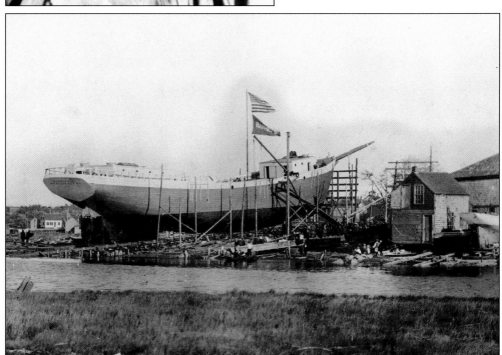

The *Harriet B.* was one of three large tern schooners built for Sen. Jesse H. Metcalf of Providence, Rhode Island. After building eight vessels in four years, Owen Lantz was forced out of business in 1920 by a postwar economic decline.

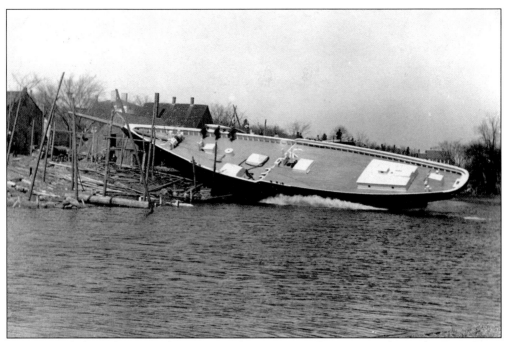

An Essex side launching was the most popular way to send a new vessel into the Essex River and made for a very exciting event. In this photograph, three men hang on to the rail of the schooner *Mary* as it launches from the A.D. Story yard in 1912. This is a beautiful view of a classic Essex side launching and reveals the deck arrangement of a typical Essex schooner. (E.J. Story photograph.)

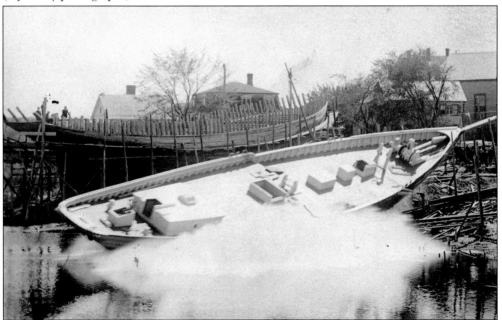

The schooner *American* was launched in 1921. By this time, launchings happened far less often than in the 19th-century heyday of Essex shipbuilding, and they became occasions for family outings and the subjects of amateur photographers.

The schooner *Emerald* is seen ready for launch. It has been eased over onto its starboard side, and greased slabs are in place below the keel. Blockings separating the greased slabs will be knocked out, and the vessel will slide down the ways on one bilge, righting itself once afloat.

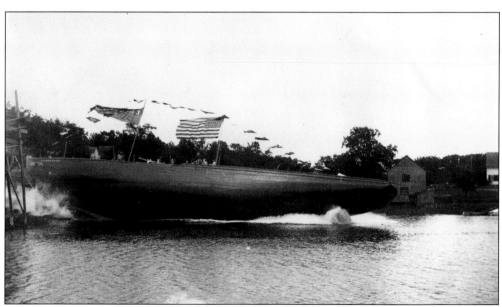

The *Emerald* plunges into the Essex River basin on its starboard side. The side launching method was preferred by shipbuilders because it was considerably less expensive than building a launching cradle, although it did pose a slightly higher risk. Occasionally, if a vessel had important investors or was expected to draw a large crowd, it would be launched in a cradle.

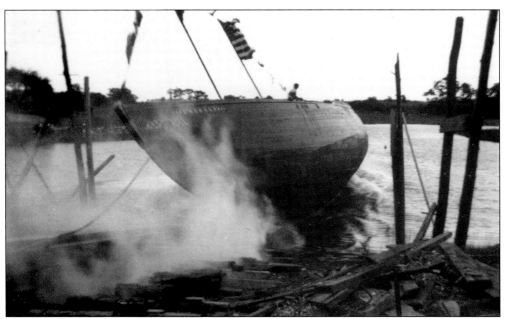

Smoke rises from its bilge as the *Emerald* skids down the greased ways. The vessel is bound for Boston, where it will join the large O'Hara Brothers fishing fleet.

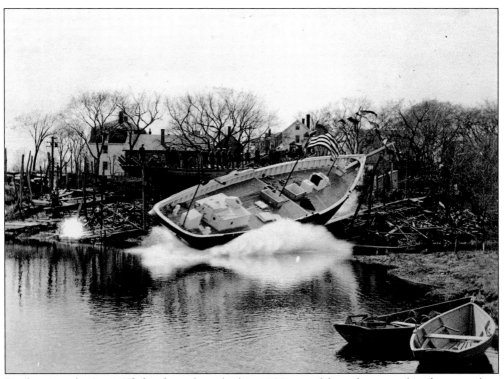

By the time the *Louis Thebaud* was launched in 1930, vessel launches were less frequent than in the old days, and they often attracted sightseers. In this view, a group uses a schooner under construction on the next slipways as a viewing platform.

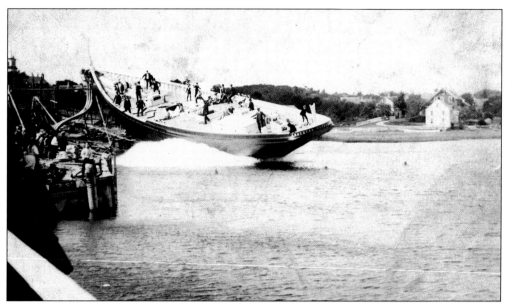

A trip down the ways during an Essex side launch was an unforgettable experience. More than a dozen people take a ride aboard the schooner *Arethusa* as it heads into the basin.

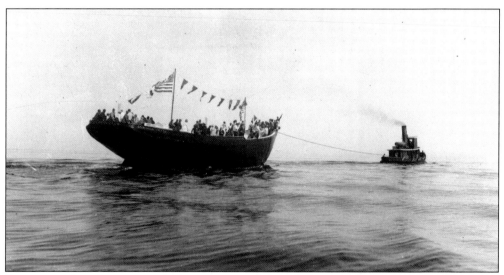

For some, a launching was a day's outing complete with a picnic lunch aboard a brand-new schooner. In this photograph, a large crowd is taking a trip around Cape Ann into Gloucester Harbor, where the *Governor Fuller* will be fitted out and readied for its maiden trip.

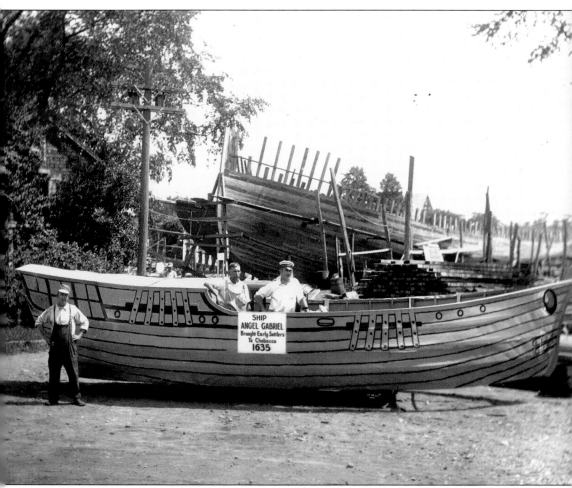

By the time Massachusetts celebrated its tercentenary in 1930, the heritage of the shipbuilding industry was an indelible part of the town's distinct character. Pictured is the A.D. Story yard's float for the celebration parade in July of that year. This tribute to the *Angel Gabriel* celebrates the vessel that brought some of Chebacco's earliest settlers from England. Standing near the stern is Billy Bagwell. Albay Muise (left) and Jacob Story man the helm. The trawler *Newton* rises in the A.D. Story yard in the background. (E.J. Story photograph.)

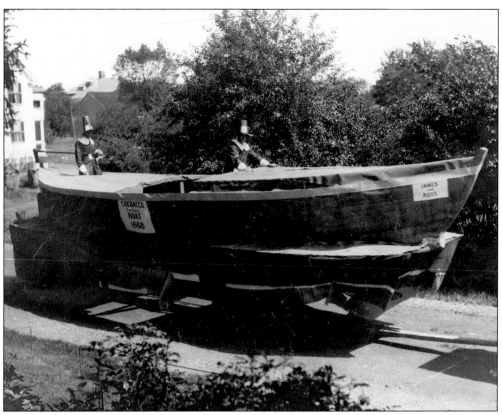

The James shipyard's float in the parade was a replica of a Chebacco boat. Chebacco boats originated in the parish of Chebacco in Colonial times and established its reputation for quickly built vessels that were seaworthy yet inexpensive. (E.J. Story photograph.)

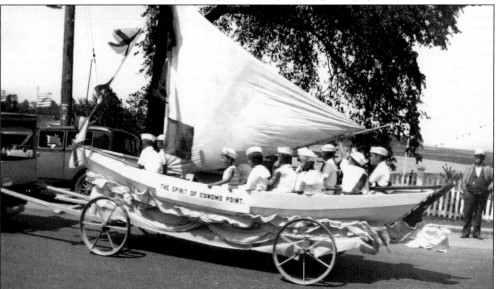

Even the neighborhood of Conomo Point celebrated its nautical past with a boatload of young sailors.

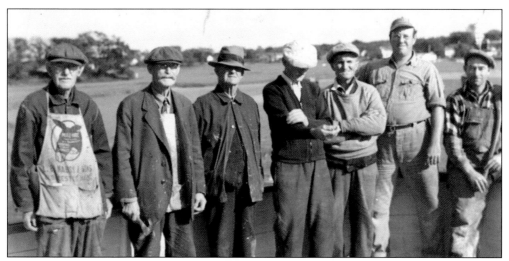

Shipbuilding in Essex had slowed considerably in the 1930s, but a postwar economic boom brought back a brief reprise of the industry in the 1940s. Pictured, from left to right, are Harry L. Story, Edwin C. Perkins, John Prince Story, Stephen Price, Leander Doucette, Jonathan Story, and Alphonse LeBlanc.

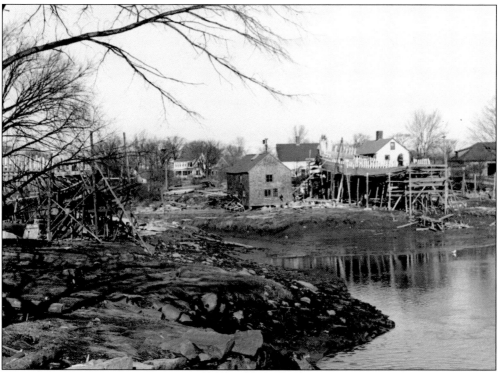

This view from the causeway shows the Essex River basin in 1946. Vessels to the left are going up in the Dana Story yard, and straight ahead is the Burnham yard, used at that time by Jonathan Story. (Dana A. Story photograph.)

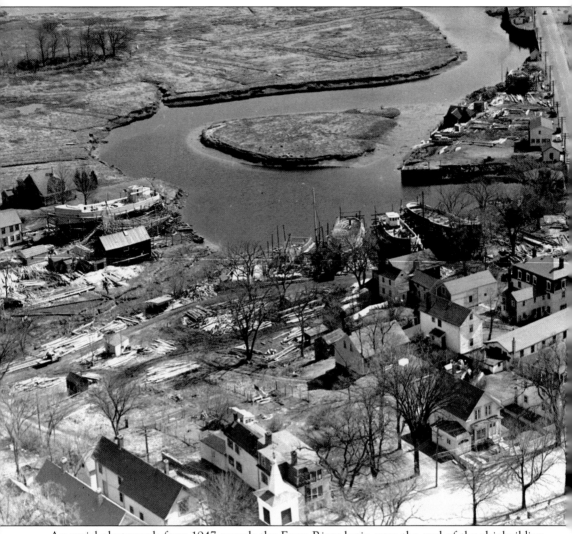

An aerial photograph from 1947 reveals the Essex River basin near the end of the shipbuilding industry. The age of sail now long past, only diesel-powered draggers are being built. To the left is the Jonathan Story yard, with the 115-foot *Mother Ann* and the *St. Rosalie* in frames. Toward the center is the Dana Story yard, with four vessels in different stages of construction—*Salvatore and Grace*, *Mary and Josephine*, *Famiglia II*, and *Kingfisher*. To the upper right is the James yard, with *Bright Star*. The following year, only two vessels were launched for the fisheries. The year 1949 marked the end with the launch of the schooner yacht *Eugenia J*. (Norman P. Swett photograph.)

Two

THE STORY DYNASTY

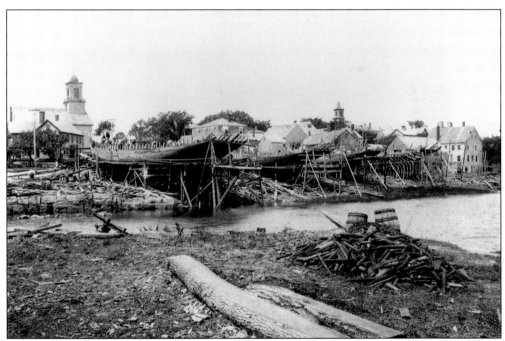

Seven generations of Storys built vessels on this yard near the town landing. In this photograph, shipbuilder Moses Adams is building a schooner on the town landing (far left), and Arthur D. Story has three vessels under construction. This yard was purchased in 1993 by the Essex Historical Society and Shipbuilding Museum to help preserve and interpret the work of the Story family and all the shipbuilders of Essex. (G.W. Harwood photograph.)

Abel Story (1791–1863) was a fourth-generation shipbuilder and the founder of the family firm at the Essex River basin, having gone into business at that location with shipbuilder Adam Boyd in 1813. The early 19th century was a time of tremendous growth in town, a primary reason for its secession from Ipswich in 1819. His shipyard and other business interests in town made Abel Story one of the most prosperous citizens in Essex.

Abel's son Job Burnham Story (1817–1893) carried on the family enterprise. His schooner *Moses Knowlton* sailed to the Azores on its maiden trip, with his 17-year-old son, Lyndon, serving as master.

Arthur Dana Story (1854–1932) has the distinction of being the most productive shipbuilder in the history of Essex. He began his career in 1873 at the age of 18. When he passed away in 1932, he had built a total of 429 vessels. (E.J. Story photograph.)

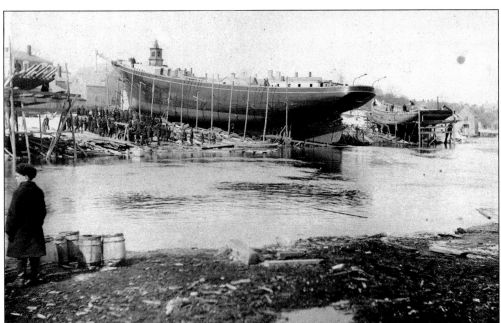

A.D. Story launched his largest vessel in the spring of 1891. The three-masted schooner *Warwick* of Providence, Rhode Island, was about 152 feet in length and 610 gross tons. Unlike most Essex-built vessels, the *Warwick* was a centerboard schooner with a flush deck.

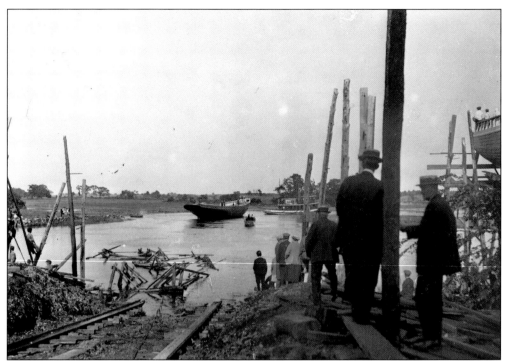

A.D. Story's *Yankee* was launched in 1921. The remains of the launching cradle can be seen at the end of the ways. The *Yankee* was another one of many vessels that the Story yard produced for the O'Hara Brothers of Boston.

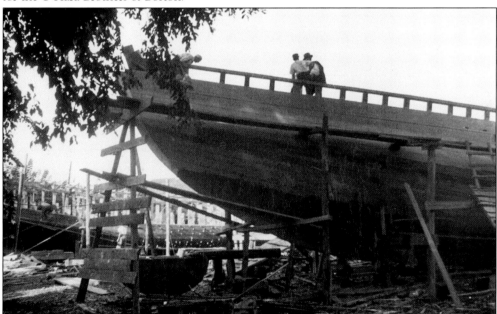

The *Evelina M. Goulart* was designed by A.D. Story's son Jacob. Built in 1927 for a Portuguese family in Gloucester, the *Goulart* spent nearly six decades in the North Atlantic fisheries. Today, it sits at the shipyard, where it is being developed as a permanent exhibit about Essex shipbuilding. (William D. Hoyt photograph.)

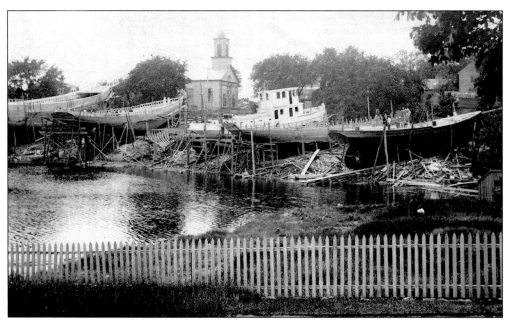

In June 1924, A.D. Story had six vessels under construction. From left to right are *Adams* (built on speculation), *Emerald, Annie and Mary, Protector* (for the Massachusetts State Police), *Minna M.*, and *America*, ready to launch. (E.J. Story photograph.)

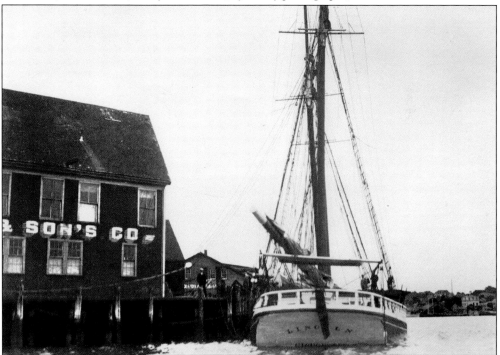

A.D. Story was a businessman whose interests went well beyond shipbuilding. Among his enterprises was the three-masted *Lincoln*, which he built in 1919 for use as a coasting schooner, carrying cargoes of potatoes, lumber, and coal from Maine and the Maritimes to Gloucester, Boston, and New York.

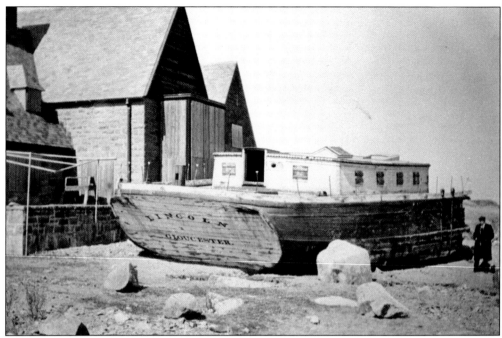

The *Lincoln* was a profitable enterprise until it was rammed by a steam collier in 1928. Its large cargo of lumber kept it afloat, and it was towed to Gloucester, where it was declared a total loss. Here, a portion of the vessel lies stranded at Eastern Point.

The keel of the *Adams* was laid in 1920, but the vessel was not launched until 1929. A.D. Story began the vessel on speculation when the shipbuilding business was enjoying a postwar boom. The market soured, however, and the *Adams* sat upon the ways, its bowsprit jutting out over Main Street for more than eight years. During that time, it became a landmark in town and even hosted a nest of bees.

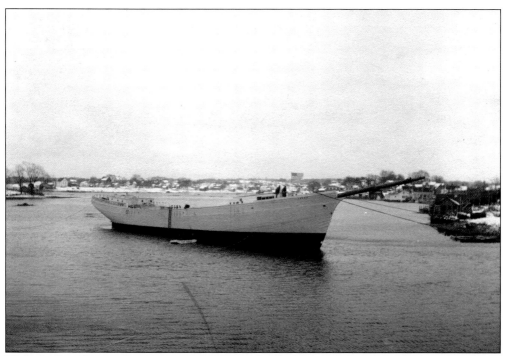

With the *Lincoln* out of commission, A.D. Story finally launched the *Adams* during a snowstorm on April 13, 1929. It was the last three-masted wooden commercial vessel to be launched in the United States.

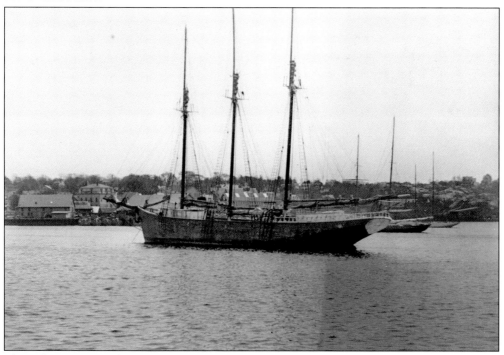

The *Adams* continued the coasting trade, carrying cargoes to Boston, New York, Philadelphia, and occasionally Cuba.

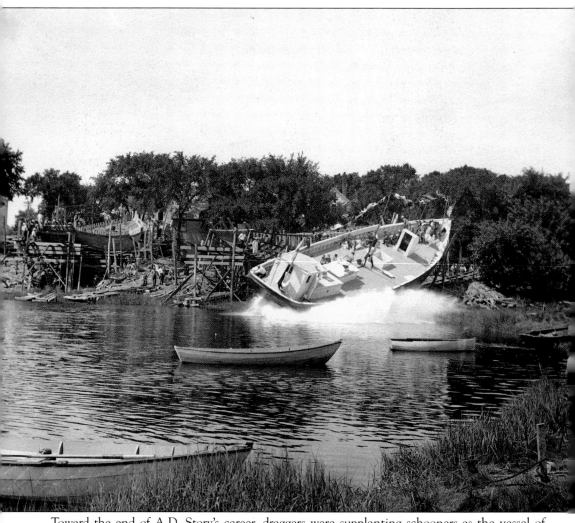

Toward the end of A.D. Story's career, draggers were supplanting schooners as the vessel of choice for fishermen. The *Ruth Lucille*, pictured here at its launching on July 20, 1929, sported a pilothouse and an engine, but its hull retained the lines of the classic Essex fishing schooner. The 1920s have been termed the transitional era in vessel building, when fishing fleets were rapidly converting from sail to power.

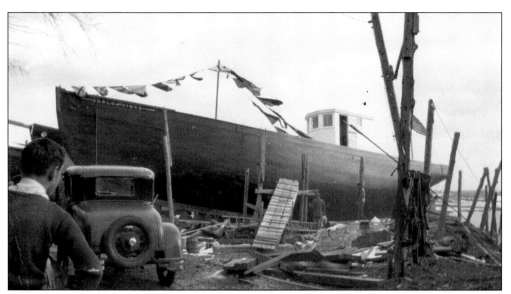

The dragger *Carlo and Vince* was built for members of the growing Italian community in Gloucester. Launching day was February 23, 1932, and it would prove to be the last one attended by A.D. Story.

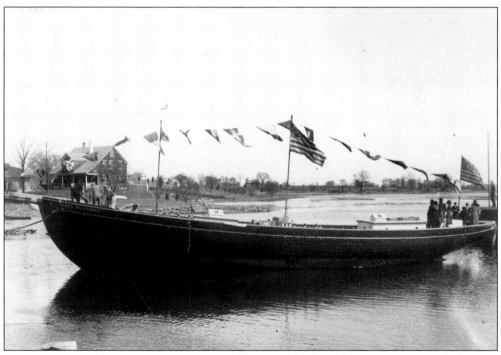

It is April 20, 1932, and the yacht *Jessie Goldthwaite*, the last of A.D. Story's vessels, has just been launched. A.D. Story died on March 5, 1932, the same day that Everett James launched his last vessel.

Jacob Story took over operations of the yard after the death of his father. It proved to be a trying time in shipbuilding or any business endeavor as the Great Depression settled in. The year 1933 was the first on record in which a vessel was not launched in Essex. (John Clayton photograph.)

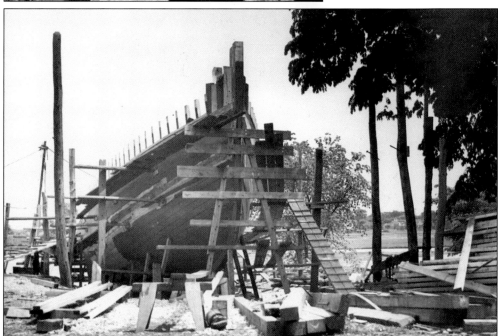

The dragger *Joan and Ursula*, launched in 1937, was one of only a handful of vessels built in Essex during the Great Depression years. With the exception of only one vessel, Jacob Story was the only builder working in town from 1932 to 1938.

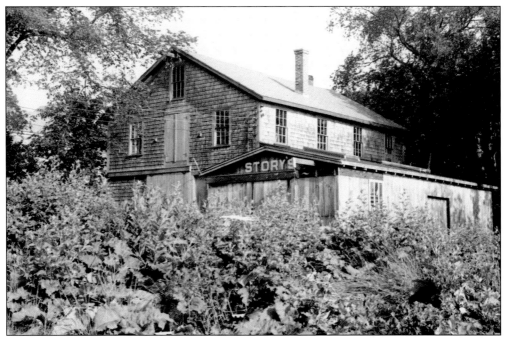

After Jacob Story's sudden death in 1939, the shipyard property languished for several years. In 1944, Dana Adams Story, A.D. Story's youngest son and Jacob Story's half-brother, decided to carry on the family business. He was the fifth generation to build vessels in the same yard.

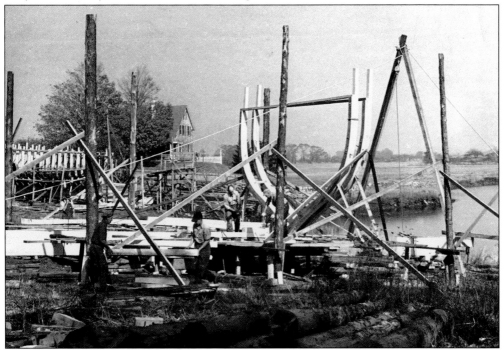

With the first few frames of the dragger *Benjamin C.* in place, the Story yard was once again in business. The Jonathan Story yard, on the Burnham family property, can be seen in the distance to the left.

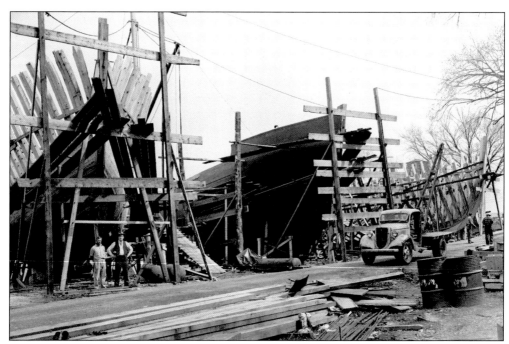

In 1946, the Story shipyard was in full operation. Dana Story (right) and his foreman Albert Doucette stand below the stem of the *St. Nicholas*. The *Benjamin C.* is nearing completion, and to the right is the *Famiglia II*. (Norman Swett photograph.)

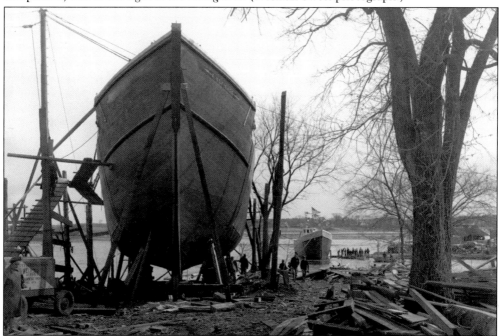

It is March 22, 1947, and the *Famiglia II* has just been launched. Three days later, the *Kingfisher* headed down the ways. Despite the flurry of activity, this year effectively marked the end of the Essex shipbuilding industry. In 1948, only one vessel, the dragger *Felicia*, was launched from the Story yard.

Economic factors finally put an end to Essex shipbuilding in the late 1940s. The World War II production of steel-hulled vessels had given birth to an efficient steel shipbuilding industry. This presented a new and more practical option for commercial fishing vessels. Dana Story transformed the shipyard into a boatyard for storage and repair while continuing to construct smaller working and recreational vessels. (Charles Low photograph.)

Dana Story's son Brad continued the family tradition building until the 1990s. Here, he cuts the rabbet on *Odd Lot,* a 33-foot motor cruiser built in 1975–1976. Brad Story represents the ninth generation of Story shipbuilders. (Richard Story photograph.)

The Story boatyard, pictured in the fall of 1962, reflects the changes in Essex and in the local maritime economy. For the first time, pleasure craft far outnumbered the working vessels at the Story yard.

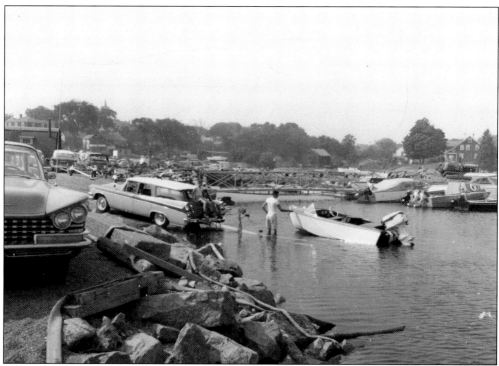

For three centuries, the Essex River basin was a workplace where rugged fishing vessels were constructed year-round by hardworking craftsmen from sunrise to sunset during six-day weeks. By the late 20th century, the focus of the Essex River basin had shifted decidedly from work to recreation.

Three

THE JAMES SHIPYARD

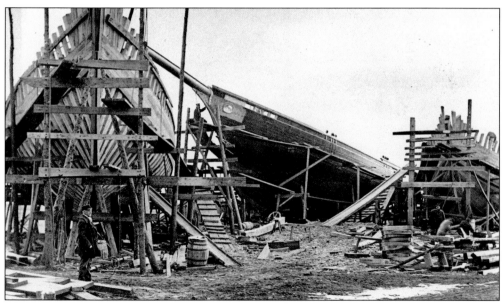

The James family of shipbuilders was the other great shipbuilding firm operating in Essex in the late 19th and early 20th centuries. The shipyard, located where Perkins Marina is today, was reputed to have turned out vessels of yacht-like quality, whether crafted for a yachtsman or a fisherman.

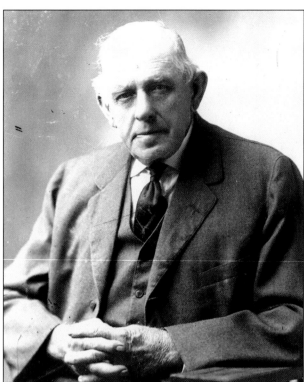

John Frank James was one of the town's outstanding shipbuilders. His father, John James, established the family business in Essex in 1837. Upon the retirement of his father in 1885, John F. James entered into a long and prosperous partnership with Washington Tarr.

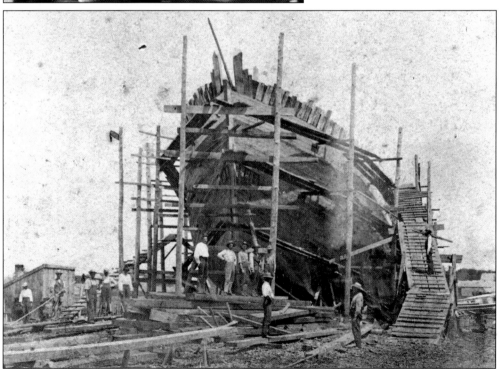

John James and Leonard Mackenzie built the *Mattie W. Atwood* in 1872. At 653 gross tons and about 165 feet in overall length, this three-master was the largest sailing vessel ever built in Essex.

Washington Tarr was born in Rockport and, in 1867, married into the James family. The firm of James & Tarr (or Tarr & James, as it became more commonly known) operated until 1912, when Washington Tarr retired.

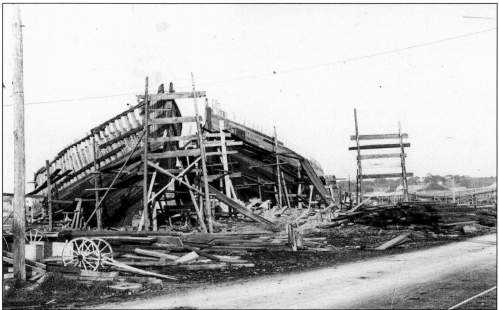

Space was always at a premium at the James & Tarr yard. Three vessels were the most that could be constructed simultaneously, although there were usually no more than two on the ways at any given time. Today, this site is occupied by Perkins Marina, owned by a family that descends from the James family of shipbuilders.

The sawmill and lumber-storage area for the James yard was located on the old Corporation Wharf, today Pike's Marina.

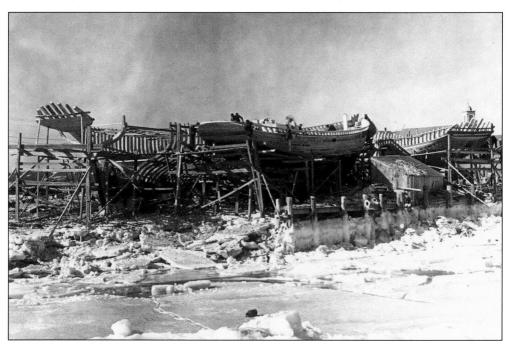

In the James yard, as in all the Essex shipyards, vessel building went on six days a week, nine hours a day, year-round, and in almost any weather. This photograph, taken in the winter of 1901, reveals the frozen Essex River, where the ice sometimes approached 20 inches in thickness.

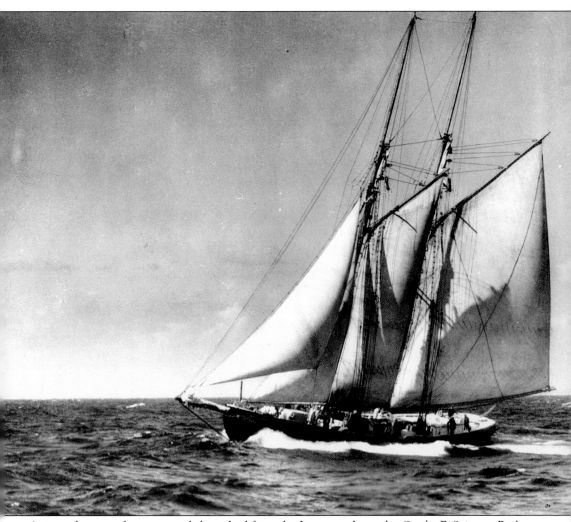

Among the more famous vessels launched from the James yard was the *Oretha F. Spinney*. Built in 1920 for Gloucester's Capt. Lemuel Spinney, this schooner played the role of the *We're Here* in the 1936 MGM production of *Captains Courageous*. The *Spinney* was originally a knockabout schooner designed by Thomas F. McManus. The bowsprit was a later addition. Gloucester's historic landmark, the 1926 schooner *Adventure*, is believed to have been built off the molds of the *Oretha F. Spinney*.

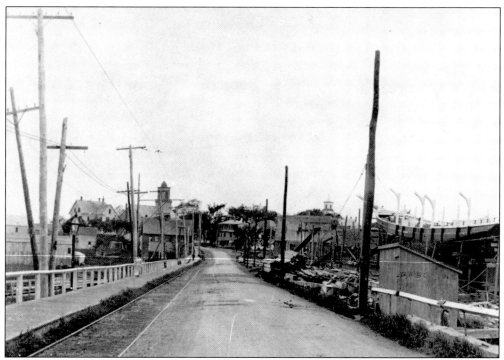

The last wooden whaler in the United States was launched from the James & Tarr yard in late May 1910. The brigantine *Viola* was built for Capt. John A. Cook, who registered the vessel in Portland, Maine. It disappeared on a whaling voyage in 1917, and it was speculated that it might have been the victim of a German U-boat.

This photograph of the James & Tarr yard from the basin affords a good view of the Rocky Hill district in the distance. The train trestle carrying the tracks of the Essex Branch of the Eastern Railroad to Conomo Station is also visible.

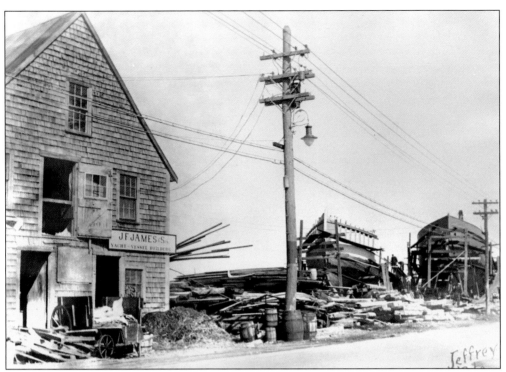

With Washington Tarr's retirement in 1912, the firm became known as John F. James & Son. Everett B. James had been working in his family's yard for many years. After his father's death in 1920, Everett James assumed control of all operations and continued the James family's commitment to fine workmanship.

Everett James was also a man of high social standing in town, having served as a selectman and on many town committees. He was also known as an exceptional vocalist and sang in the Universalist church choir for 55 years.

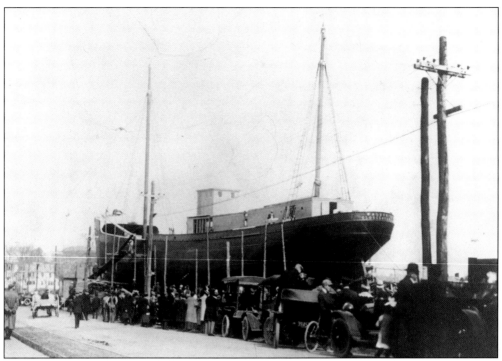

The steam trawler *Walrus* was built in 1917 for the Gorton-Pew fisheries in Gloucester. It was another of the James family's largest vessels, 173 feet in length and 479 gross tons. A slightly smaller sister ship, the *Seal*, was built next door in the Story yard at the same time.

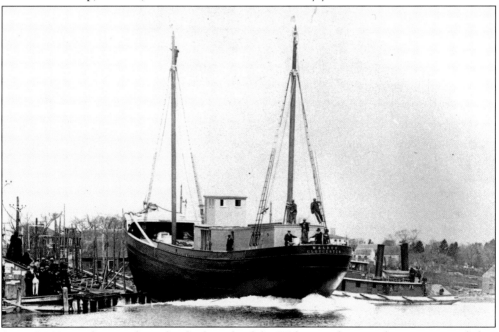

Some 2,000 people turned out for the launch of the *Walrus*, and two tugboats were needed to get it out of the river. It was the first large beam trawler launched in Essex. The vessel was launched rigged with its masts in place—an unusual occurrence in Essex by this time.

Lyman James, Everett's brother, was the last member of his family to operate the James shipyard. He had been a grocer before taking over the family business, so he employed a veteran builder, 80-year-old John Prince Story, to oversee his first project, the dragger *Gov. Saltonstall*.

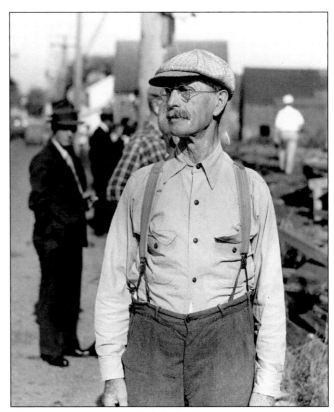

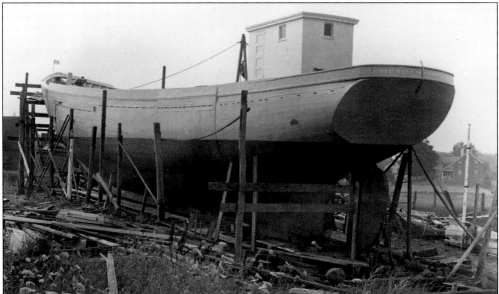

Between 1940 and 1944, Lyman James launched six draggers. The *Columbia* (pictured) had a hull shape reminiscent of the old-time Essex schooners, but times had changed since the days of the schooner. Lyman James, as well as other shipbuilders trying to operate in the 1940s, was working against the odds—suitable shipbuilding timber was getting scarce, skilled workers were difficult to find, and the demand for wooden vessels was fading.

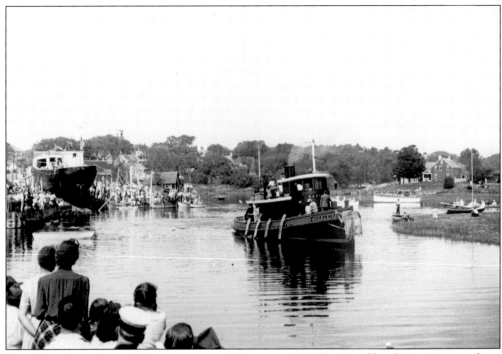

Some Essex launchings did not go as smoothly as most did. The *Ronald and Mary Jane* stuck on the ways while a crowd of onlookers anxiously awaited its plunge into the river. The Gloucester tug *Mariner* tried to get it started three times but snapped a six-inch hawser each time.

The *Ronald and Mary Jane*'s owners had a special guest at the James yard that day, so a timely launching was important. Here, shipyard workers try to determine what has the vessel hung up.

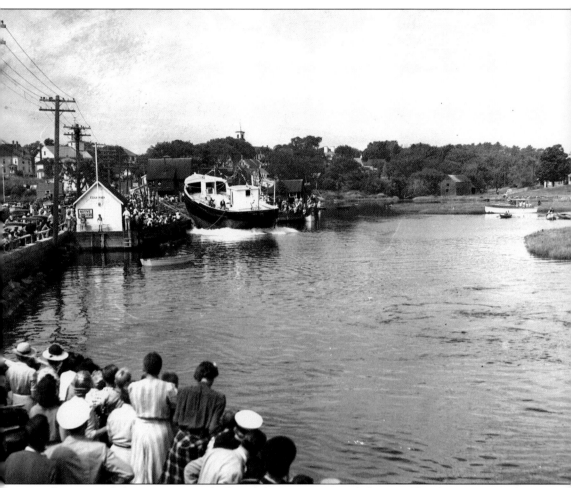

Finally, a 12-inch hawser was attached, and the *Mariner* started the *Ronald and Mary Jane* with just one pull. The dragger was not the star of the show that day, however. Comedian and actor Al Jolson, a friend of the vessel's New York owners, had come to attend the launching. This fact, rather than anything special about the new dragger, accounted for the large crowd in attendance. The whole ordeal took so long that Jolson left an hour or so before the actual launch, but he entertained the crowd and the media while the shipyard gang and the *Mariner's* captain puzzled about the stuck vessel.

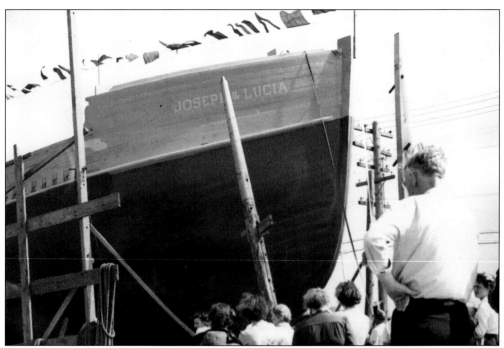

Lyman James's last dragger was the *Joseph & Lucia*, built for the Brancleone family of Gloucester, one of the Italian fishing families from Gloucester. They were the primary customers of the Essex shipyards in the 1940s. (Robert F. Sherman photograph.)

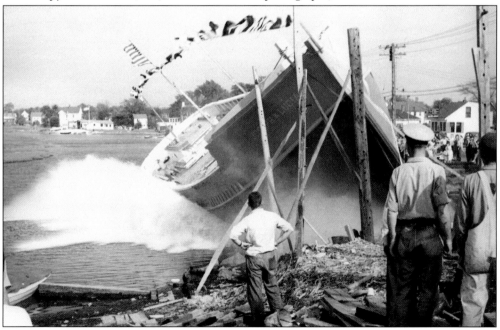

The *Joseph & Lucia* was launched on May 26, 1944. What was intended to be a traditional Essex side launching turned into somewhat of a disaster. The smoke seen near the bow was caused by hot grease as the hull scraped along a rock. The vessel needed to be hauled and repaired immediately when it arrived in Gloucester. (Robert F. Sherman photograph.)

Four

THE MEN OF THE SHIPYARDS

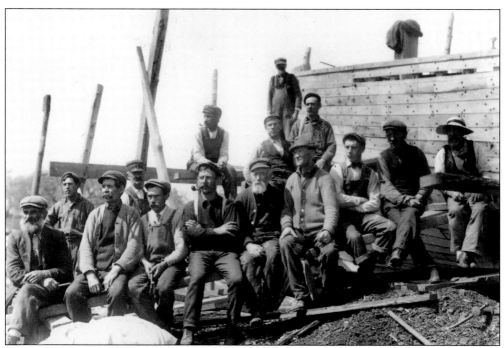

Shipbuilders acquired the land, secured contracts (often as simple as a handshake), and hired the men necessary to build a vessel, but they never wielded an adz or a broadax. The work of crafting a vessel was conducted by the shipyard gang and a handful of other craftsmen. Here, the A.D. Story yard gang takes a brief moment from a busy workday to pose for a photographer. (E.J. Story photograph.)

Edwin James Story was the brother of A.D. Story. He occasionally worked in the Story yard, molding timber, but he was more artist than laborer. "Eddie James" preferred playing the oboe, clarinet, and English horn. He even played with the Ringling Brothers Circus at one point. Most significantly, however, he was the town's earliest photographer, documenting much around Essex and especially in his brother's shipyard. He left behind a rich archive of photographic history, which formed the bulk of this collection. (E.J. Story photograph.)

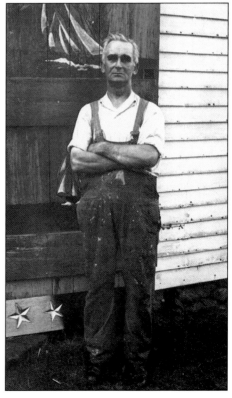

Lewis H. Story carved the scrollwork and name boards on vessels and was a self-taught vessel designer and modeler. This allowed him to make ends meet while he pursued his life's passion—compiling as complete a record as possible of all of the vessels built in Essex. He probed back into the earliest records of the Massachusetts Bay Colony and formed the foundation for much that is known about the history of Essex shipbuilding today.

A.D. Story yard foreman J. Horace Burnham was a veteran of the Civil War and, for the remainder of his life, was active in the Grand Army of the Republic. He was also a vessel designer, having modeled the *Boyd & Leeds*, built in 1894, from which 17 more vessels were constructed over the next seven years.

A native of Prince Edward Island, Edwin Hobbs spent the early part of his career building vessels in Cleveland on Lake Erie. When he returned to Essex, he worked at the John James yard and, in 1876, established his own business on the Oliver Burnham property, at the end of Burnham Court.

Marcius Lufkin was a blacksmith in late-19th-century Essex. Although blacksmiths operated separately from the shipyards, they played a vital role in the shipbuilding industry. Among other things, they made and repaired tools and cast the iron fittings onto which a vessel's rigging was attached.

Blacksmith Otis Story and family pose for Edwin James Story. While many families in Essex depended on work in the shipyard, there were many more in related trades who depended on the prosperity of the shipbuilding industry. Ropemakers, coopers, farmers, and grocers all had a stake in Essex shipbuilding.

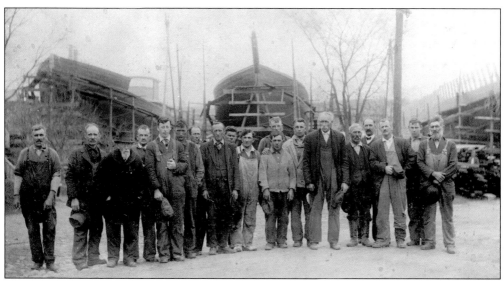

The Story yard gang gathers for photographer Eddie James in May 1918. From left to right are Bill Atkins, John Murphy, Willie Scroons, ? Norwood, Elbridge Perkins, John Hubbard, Stanwood "Needles" Burnham, Bill Swett, ? Davis Jr., Isadore Boutchie, Frank White Story (back), Peter Hubbard (front), J. Horace Burnham (foreman), R.Z. Davis, Oscar Woods, Alden Burnham, Arthur Doyle, and Mose Bushey. The vessels under construction are, from left to right, the *Roseway, Aviator,* and *Lincoln.* (E.J. Story photograph.)

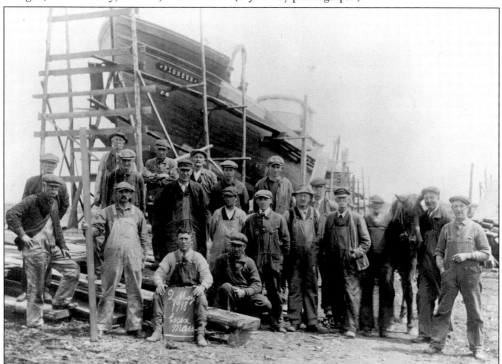

Taken on May 2 (probably the same day as the previous view), this photograph features the James yard gang in front of the *Pioneer,* the first diesel-powered beam trawler built in Essex. Tony Bevilacqua, a first-generation immigrant from Italy, is holding the sign. (E.J. Story photograph.)

Elbridge Perkins was an inboard joiner who would also build houses on the side when the shipyards were slow. Many houses in town feature woodwork very similar to the cabins of Essex-built schooners. The Perkins family was known for exquisite workmanship with fastidious attention to detail. (E.J. Story photograph.)

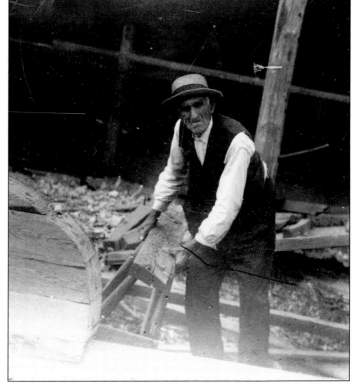

Charles Oliver Story, pictured in his 90s as he works on a rudder in the A.D. Story yard, was a shipbuilder and designer as far back as the 1850s. He is but one example of many Essex men carrying on in the shipbuilding trade well into their advanced years. (E.J. Story photograph.)

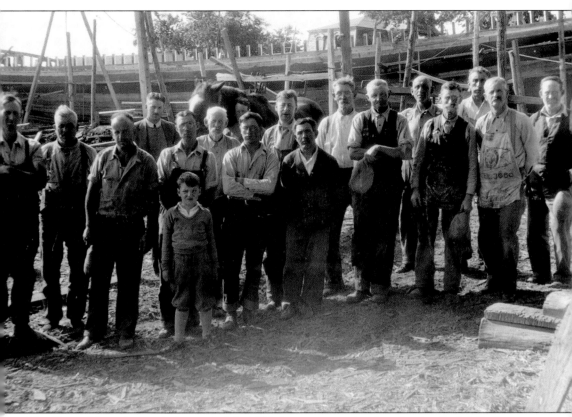

The Story shipyard gang is shown in July 1932, just two months after the death of A.D. Story. From left to right are Walter Cox, Bill Atkins, Dan Languedoc, Jake Story, unidentified, George Claiborne, Sammy Gray, Albert Doucette, Elbridge Perkins, Pete Hubbard, Frank McIver, Frank White Story, Phil Terrio, Ed Perkins, Albay Muise, Alden Burnham, and Stanwood "Needles" Burnham. The boy standing in front is Benny Bickford.

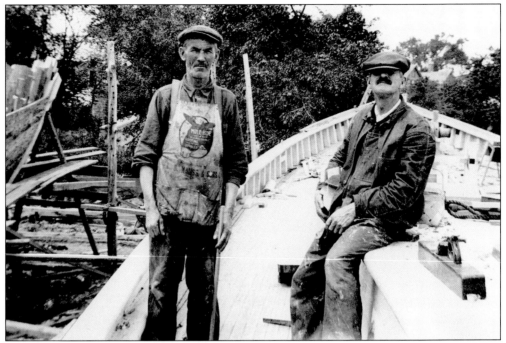

Jack Doyle (left) was the ultimate expert in the construction of the forecastles of Essex-built schooners. Alden Burnham (right) was A.D. Story's yard foreman for many years and also operated a carpentry business with his brother Oliver Perry Burnham across Burnham's creek. Both were working in the A.D. Story yard at the time of this photograph. (Howard Gilbert photograph.)

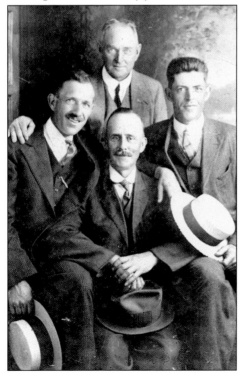

This portrait was taken during an outing at Old Orchard Beach on July 8, 1917. Standing is Epes Sargent. Seated, from left to right, are Marshall H. Cogswell, Albion Riggs, and Ed Butler. These men worked at the James shipyard at that time.

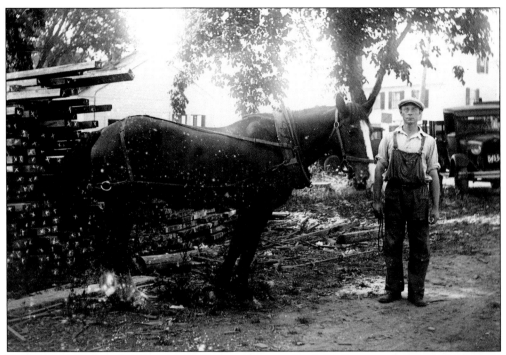

Yard horse Jimmie is led by a young George Story in the A.D. Story yard. George Story went on to become one of the best caulkers in town and, in his later years, demonstrated his craft to younger generations. He was also an accomplished musician and could play several instruments by ear.

Sammy Gray was a well-liked shipyard character. He worked at the A.D. Story yard, hauling timber, painting, puttying, and doing whatever else might be needed. In the last years of the shipbuilding business, he was a sawyer for the Lyman James yard. (Dana A. Story photograph.)

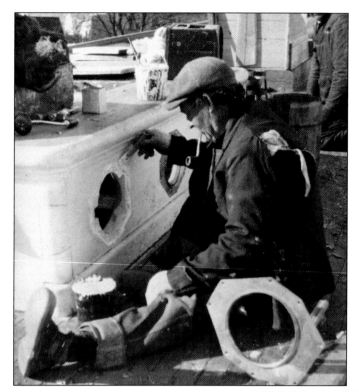

Stanwood "Needles" Burnham is cutting a port light in the side of a new cabin trunk in January 1932. This was one of his specialties. His nickname was conferred upon him because he was known to sport long, pointed-toe shoes. Wearing an old suit jacket as an overcoat on cold days in the yard was a common custom among the shipyard gang. Caulker Bill Atkins can be seen in the background. (Dana A. Story photograph.)

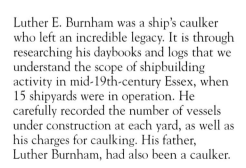

Luther E. Burnham was a ship's caulker who left an incredible legacy. It is through researching his daybooks and logs that we understand the scope of shipbuilding activity in mid-19th-century Essex, when 15 shipyards were in operation. He carefully recorded the number of vessels under construction at each yard, as well as his charges for caulking. His father, Luther Burnham, had also been a caulker.

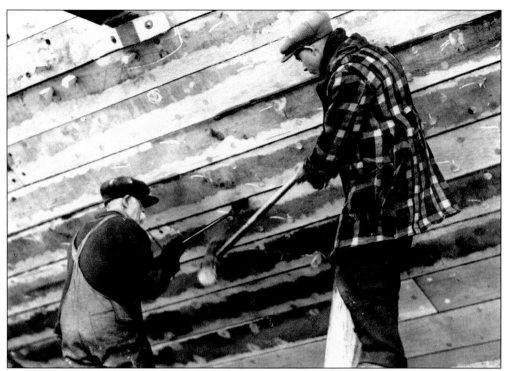

Luther E. Burnham passed on his caulking skills and his love of Essex shipbuilding history to his son Luther T. Burnham. Here, father and son are horsing in oakum (tarred hemp) between the planks of the *Eleanor Nickerson* at the James yard in 1927.

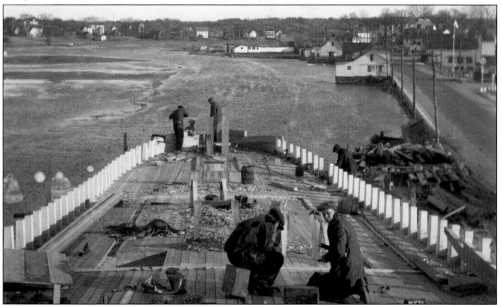

Luther E. and Luther T. Burnham (looking back over his shoulder) caulk the deck seams of the *Wanderer II* at the James yard in 1932. The younger Luther continued to caulk vessels through the 1940s. Unlike most caulkers, who used small stools with casters while working, Luther T. Burnham always caulked on his knees.

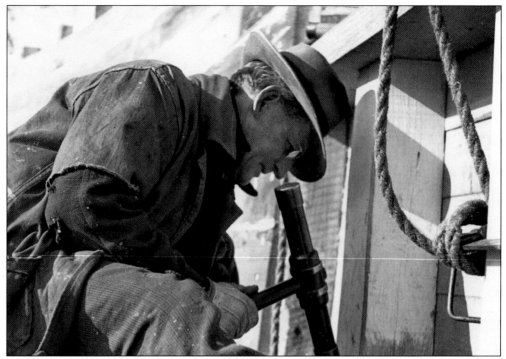

Leonard Amero caulks the *Felicia*, the last vessel launched from Dana Story's yard, in 1947. He had previously been a caulker for A.D. Story, but when work was scarce in Essex, he would go to jobs as far away as New Jersey.

John "Skeet" Doyle was an outboard joiner in the Story yard. He would scrape and plane the outside of the hull until it was smooth as glass. For most of his career, Doyle worked in concert with his partner, Pete Hubbard.

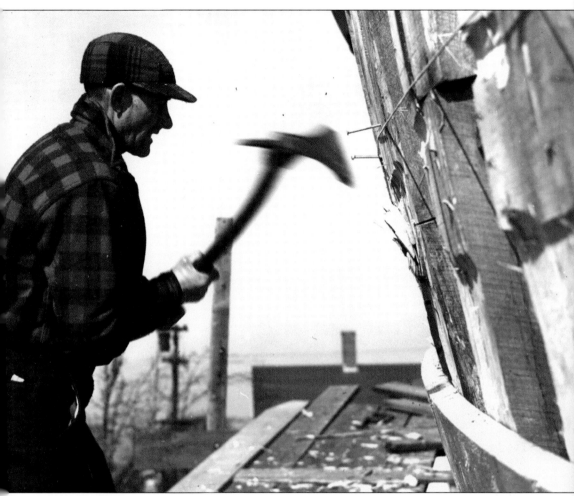

Alphonse LeBlanc, pictured dubbing the frames of a vessel so that its planking will lie flush, was one of a number of French-speaking Nova Scotians who came to work in the Essex shipyards during the early 20th century. This was the only real wave of immigration to Essex since the founders had arrived in the 17th century. The presence of French Canadians eventually prompted the establishment of a Catholic church in Essex.

Charles Hanson Andrews (known around town as Charlie Hanson) operated a spar yard in Essex. His father had also been a spar maker in town, supplying spars for masts, gaffs, booms, and bowsprits, as well as poles for derricks and flagstaffs.

Andrews's spar yard was on the upper side of the causeway bridge. In this photograph, Harry Story and Arthur Gates get out a 90-foot-long spar at the Andrews yard. Timber of this size came from Oregon and would be stored in a saltwater pen until ready for use.

Inboard joiner Edwin C. Perkins, a son of Elbridge Perkins, learned the trade at his father's side. He started as a very young man in the 19th century and worked well into his 80s during the last years of the shipbuilding industry. He worked on the interiors of everything from schooners to draggers, but the cabins for the three-masted coasting schooners were particularly elaborate and allowed Perkins to display some of his finest work. He was a man with a great sense of history, and his workshop on Story Street became a veritable museum of Essex shipbuilding heritage by end of his life.

Archer B. Poland operated out of his mold loft on School Street in South Essex until his death in 1928. Lofting was the process of taking a shipbuilder's half model, or a marine architect's lines, and scaling them up into full-sized patterns of vessel frames. It was perhaps the most crucial aspect of shipbuilding, and the Poland family excelled at it. (E.J. Story photograph.)

Willard A. Burnham (top right) was one of the last of the 19th-century Burnham shipbuilders. He claimed to have given up the business because Grover Cleveland was reelected president, but some speculated that the real reason was because he did not want to install a steam bandsaw to compete with the other shipbuilders who were converting to steam power. His son-in-law Frank Cogswell (bottom right) was an inboard joiner.

Phil Terrio, a highly skilled shipwright from a French-speaking Canadian family, worked in the Story yard. He entertained the youngsters who frequented the shipyard with his strong French accent and his ability to pass a nail though a hole in his deviated septum.

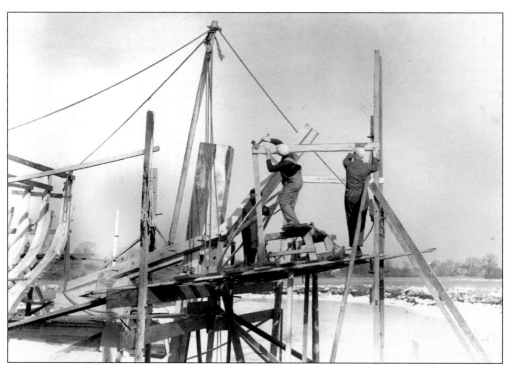

Men in the James yard are setting up the transom timbers of the dragger *Columbia* in 1942. (John Clayton photograph.)

Jim Mulcahey trims a streak's edge on the whaleback of the dragger *Felicia*, built by Dana Story in 1948. A solid shipwright, Mulcahey was also an excellent right-handed pitcher for the town baseball team and was the captain of the town's volunteer fire department.

Peter Hubbard is working on a boat repair in Dana Story's boatyard in the 1960s. In his earlier years, L'il Pete (as he was known for his diminutive stature) worked alongside his friend Skeet Doyle as an outboard joiner in the Story shipyard.

Bob D'Entremont was the sawyer for Dana Story, as his father, Liboire, had been for A.D. Story. Here, he stands outside the bandsaw shed while young Brud Doyle looks on.

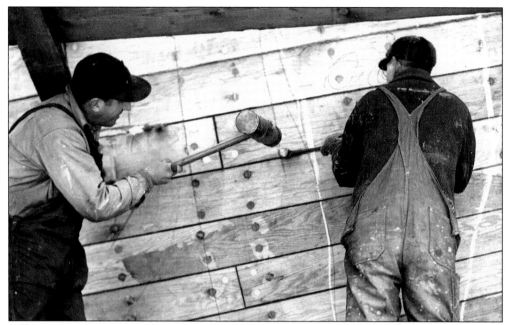

Bill Boutchie (left) and Luther T. Burnham are "making in" the oakum between the beveled seams of a vessel in the John Prince Story yard in 1945. In the busiest years of Essex shipbuilding, caulkers were very much in demand and traveled from yard to yard. In these final years, they tended to be associated with one yard at a time. (Dana A. Story photograph.)

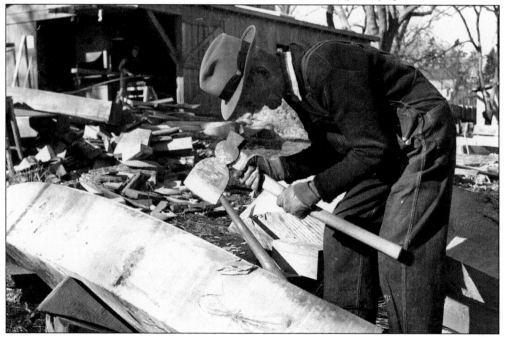

Steve Price is another example of a shipwright who stood the test of time. In this photograph (taken in the 1940s, when he was in his 80s), he is using a broadax to trim a section of a dragger's stern. He was always neatly dressed and polite and had a reputation as one of the most skilled shipwrights in town.

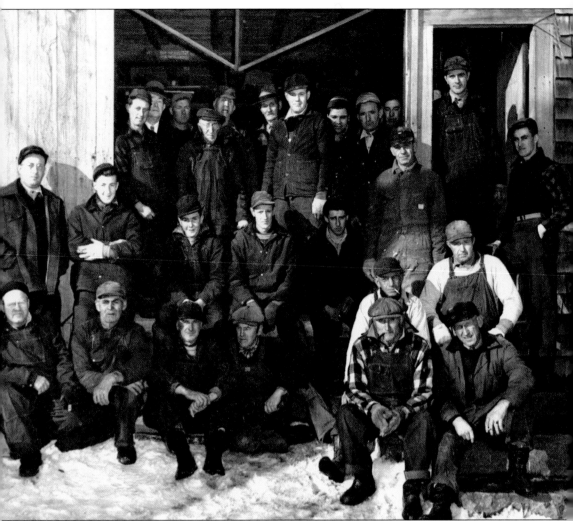

Dana Story's gang poses by the door of the shipyard shop on January 23, 1948. From left to right are the following: (front row) Charlie Baker, Charlie Conrad, Dave Languedoc, Lyn Story, John Hubbard, and Walter Cox; (middle row) Dana Story, Cliff MacKay, Clayt MacKay, Wendell Lufkin, George Doucette, Skeet Doyle, and Everett Meader; (back row, standing in doorway) Bob Graham, Jerry Hassett, Albert Doucette (foreman), Dennis Doucette, Edgar Boutchie, Steve Price, Roger Raymond, Albert Baker, Abe Manthorne, Bill Meader, Wilbur Cogswell, Earl Gates, and John Conrad.

Five

FROM FISHING CAPTAINS TO CAPTAINS OF INDUSTRY

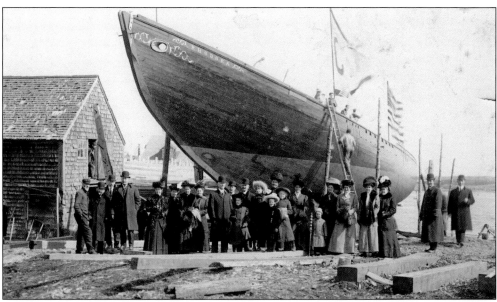

A demand for well-crafted vessels with flexible payment terms kept the Essex shipbuilding industry active for three centuries. In the early years of the industry, builders were also masters of their vessels, engaged in fishing and trading with southern colonies and the Caribbean. Demand from Gloucester's fishing industry peaked in the 19th century, and immigration and the discretionary income of wealthy industrialists continued to buoy Essex shipbuilding well into the 20th century.

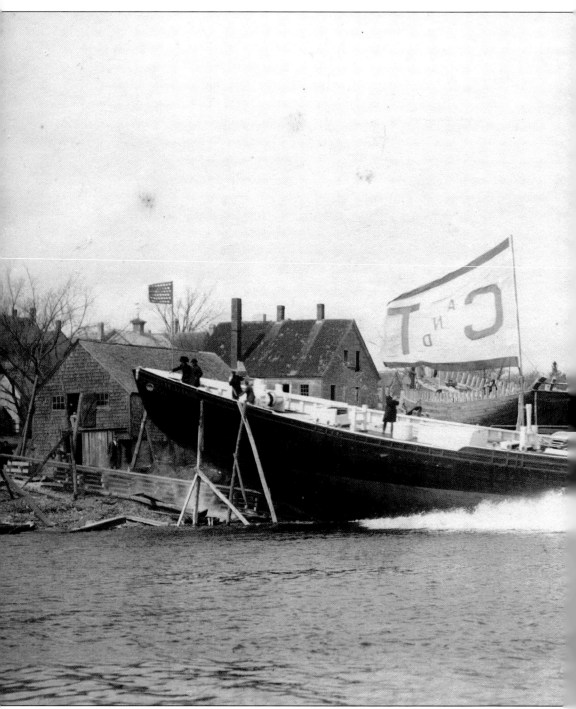

The Gloucester fisheries were by far the greatest customers of the Essex shipyards. Here, the fishing schooner *Rhodora* is launched from the A.D. Story yard on March 12, 1910. This knockabout was built for the fisheries firm of Cunningham and Thompson, one of the largest vessel owners in Gloucester. The flag amidships bears the company's ensign. The fishing and shipbuilding industries created a symbiotic relationship between the two communities that

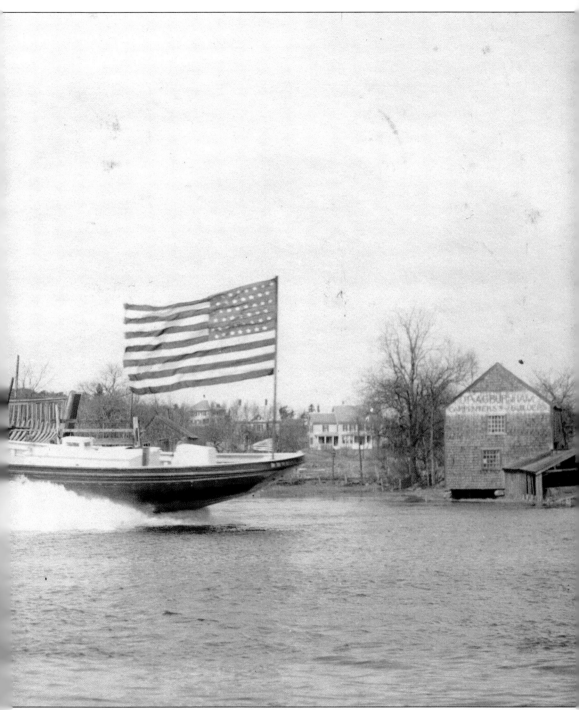

lasted until recent years. Essex shipbuilding filled the demand for vessels and supported outfitters, sailmakers, riggers, and many other businesses in the city. In addition, much of the vessel financing for Essex-built ships came from Gloucester banks. Essex shipbuilders often became investors in these vessels as well by accepting shares in the vessel in lieu of a portion of the cash owed.

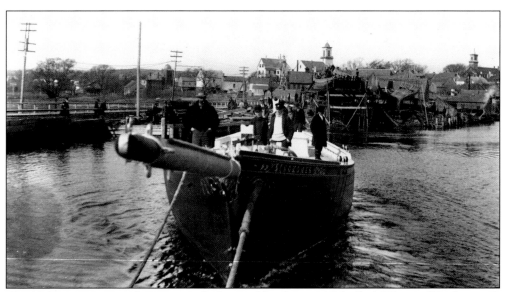

The *Nokomis* was one of many vessels designed by George Melville McLain of Rockport. A former fishing captain, McLain was a self-trained naval architect, and many of his designs were built in Essex. The *Nokomis* is believed to be the last of the vessels belonging to the John P. Wonson fisheries in East Gloucester.

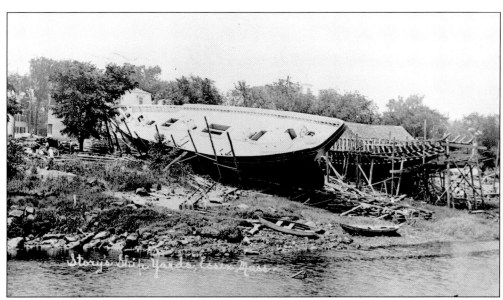

The Gorton-Pew Company was the largest and best-known fisheries firm in the business and was a leading customer of the Essex shipyards. The schooner *Nat. L. Gorton,* one of many built by A.D. Story for the firm, is pictured after a launching mishap in which one side of its sliding ways let go before the other. A.D. Story called in building movers to haul it up, and it was successfully launched a few days later.

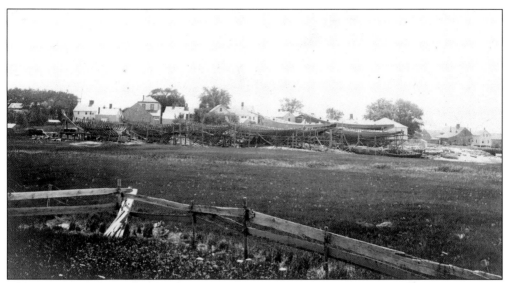

The Oxner & Story yard built a fleet of schooners for the Gulf Fisheries Company of Galveston, Texas, in 1902. Designed by noted Boston naval architect B.B. Crowninshield, they were named alphabetically. They are, from left to right, the *Aloha, Bonita, Cuba, Dixie, Elmo,* and *Fortuna.*

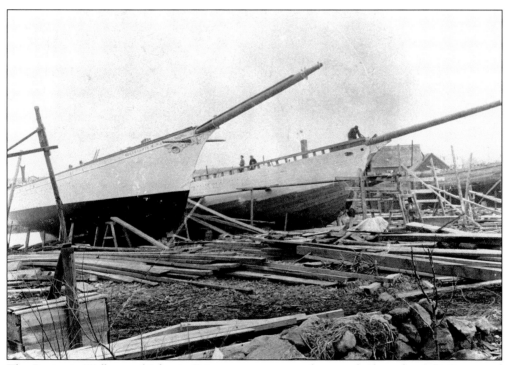

The *Benjamin Wallace* and *John A. Ericsson* were oyster schooners built at the A.D. Story yard in 1894 for New York interests. John Prince Story was subcontracted to do the construction.

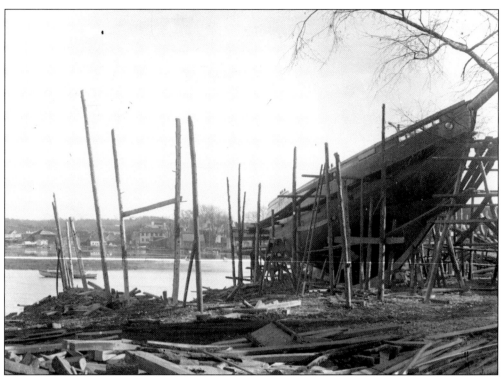

The *Ralph Brown* was launched in January 1914 for a member of Gloucester's Portuguese community. Portuguese families, mainly from the Azores, had been settling in Gloucester in large numbers since the 1870s. By the early 20th century, they were investing in their own schooners with money pooled by family and friends.

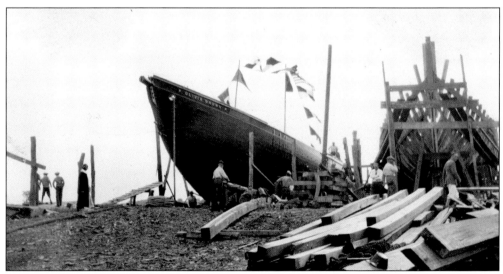

In the early 20th century, Gloucester's Portuguese became the leaders in the city's fishing industry. Their reputation as skilled fishermen and shrewd businessmen gained them the respect of the civic community as well. The *Olivia Brown* (pictured) was built at John F. James & Son in 1927. Brown was the Anglicized version of the Portuguese surname Brum.

The *Walter P. Goulart* was built in 1904 by Oxner & Story. This photograph of the vessel under sail was taken in 1911, the same year that Portuguese interests in Gloucester banded together to form the United Fisheries Association as the Portuguese fishing community's own vessel outfitter. The United Fisheries Vessel Company was created several years later to finance construction of vessels. The company remained a strong player in the Gloucester fisheries until the 1970s. (Gordon Thomas photograph.)

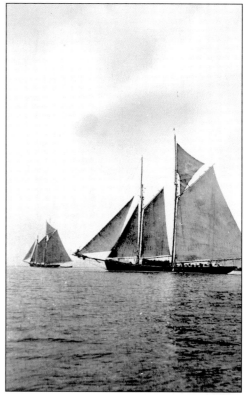

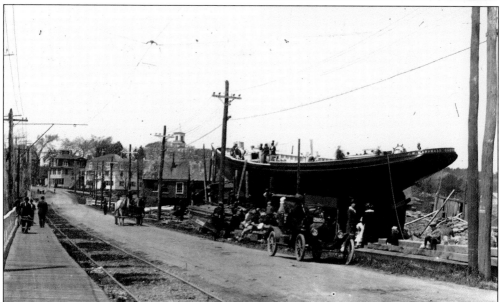

James Manuel Marshall (probably from the Portuguese name Machado) had six vessels built at the John F. James & Son yard between 1915 and 1920. These vessels became known as the Marshall Fleet. A member of a Portuguese immigrant family, Marshall became a lawyer and served as the treasurer of the United Fisheries Association. This photograph was taken soon before the May 14, 1915 launch of the *J.M. Marshall*.

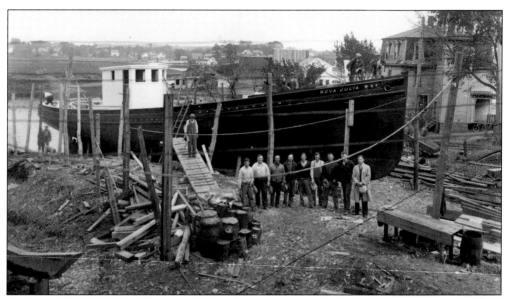

By the end of A.D. Story's career, fishing draggers were replacing schooners as the vessels of choice for fishermen. It also coincided with the rise of Gloucester's Sicilian immigrant population. Vessel ownership was seen as a means to achieving a measure of prosperity in the New World. Here, the new vessel owners stand near the bow of the *Nova Julia* just prior to launch in May 1930. There were many reasons for the change, but the quick-freezing technology developed by Clarence Birdseye in the 1920s was a major factor. Otter trawling, in which huge nets were dragged across the ocean floor, was a much more efficient means of catching more fish to meet the growing demand than the old dory trawling method.

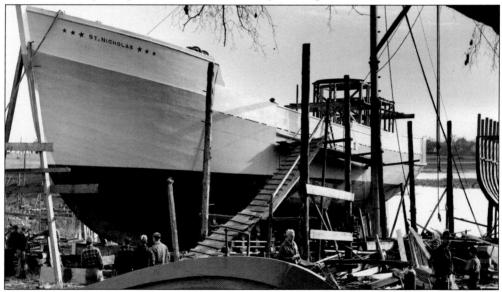

Most of the draggers constructed under Dana Story in the 1940s were for Sicilian families in Gloucester. The *St. Nicholas* was one of them, one of five draggers built in the 1940s for members of the Parisi family. One reason for the spike in demand was that redfish (also known as ocean perch) was abundant and was gaining in popularity after long being considered an undesirable fish for eating.

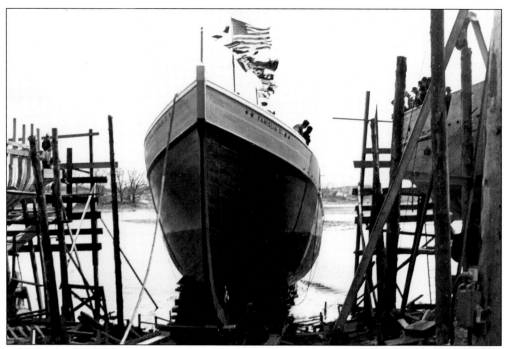

Launched as *Famiglia II* on March 22, 1947, the vessel was renamed *Agatha & Patricia* and fished out of Boston for many years.

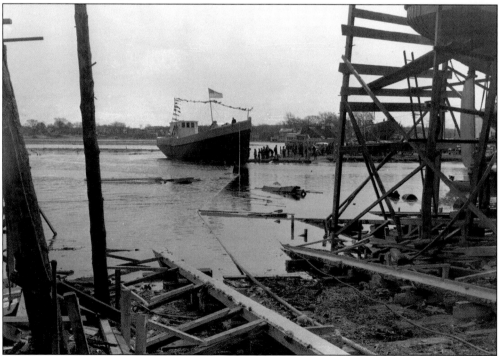

After the launch of the *Famiglia II,* the remains of its cradle can be seen in the Essex River. Dana Story elected to launch all of the vessels built under his tenure in a cradle, despite the fact that a cradle launching required much more in terms of stock and labor.

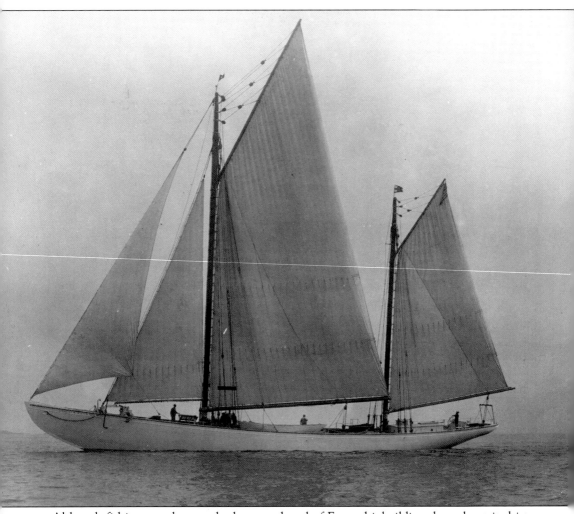

Although fishing vessels were the heart and soul of Essex shipbuilding throughout its history, many yachts were built at the Essex yards. The *Finback* was a ketch-rigged knockabout yacht that was designed by Thomas F. McManus and built for Charles Henry Wheelwright Foster of the Eastern Yacht Club in Marblehead. Foster was a vessel connoisseur—he owned 59 of them over the course of his lifetime. He had admired the work of the Story yard at a launching in 1915 and decided that he should own a deep-sea fishing vessel. The launch on May 4, 1916, was preceded by a catered luncheon at the shipyard—quite an unusual affair for Essex. The *Finback*, at 137 feet overall, was the largest yacht built by A.D. Story.

The yacht *Mariner* was built in 1922 for L.A. Norris of San Francisco. The vessel was a Starling Burgess design and reflected an inclination among yachtsmen for fishing-inspired vessels.

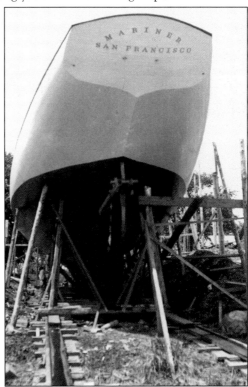

The *Mariner* won a race from San Francisco to Honolulu and another from San Francisco to Tahiti, which it finished in 21 days and 12 hours. Its success caught the eye of actor John Barrymore, who purchased the vessel soon after. (Herreshoff photograph.)

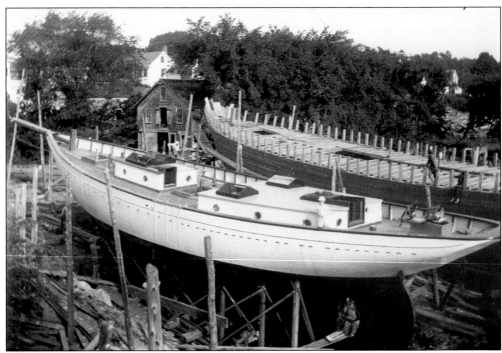

In need of a new yacht, L.A. Norris returned to the A.D. Story yard and requested the *Navigator*, which was launched in July 1926. In this photograph, seven-year-old Dana Story stands near the cabin trunk. (E.J. Story photograph.)

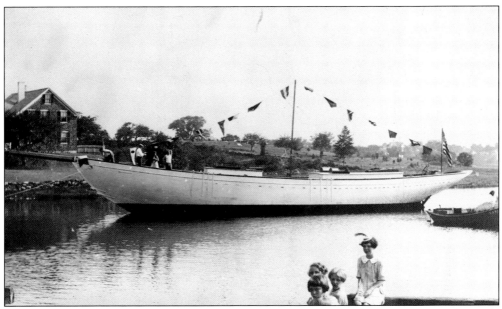

Smaller than the *Mariner*, this new yacht had another difference. The *Mariner* carried outside ballast in the form of a lead keel. This was the only A.D. Story yacht with such a contrivance. (E.J. Story photograph.)

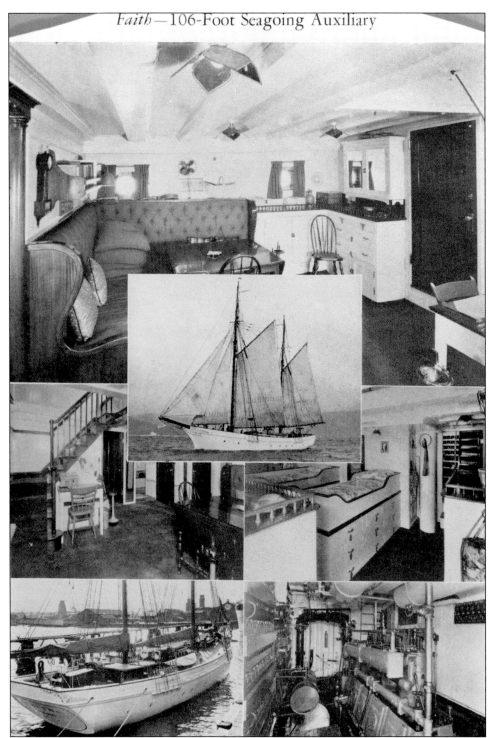

Later in 1926, the yacht *Faith* was launched for Chicago industrialist Walden W. Shaw. A ketch-rigged vessel, the *Faith* likely had the most luxurious accommodations of any Essex-built yacht.

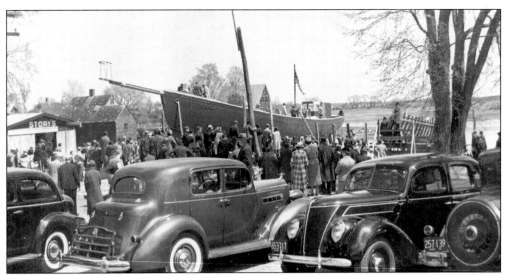

The schooner yacht *Skilligolee* was built for Quincy Adams Shaw of Beverly Farms during the winter of 1937–1938. By this time, the Story yard was under the watch of Jake Story, who also designed the vessel. Shaw requested that the vessel include a swordfishermen's striker's pulpit, which can be seen in this photograph of the *Skilligolee*'s launching festivities on May 1, 1938. This was the first vessel ever launched on a Sunday in Essex. (John Clayton photograph.)

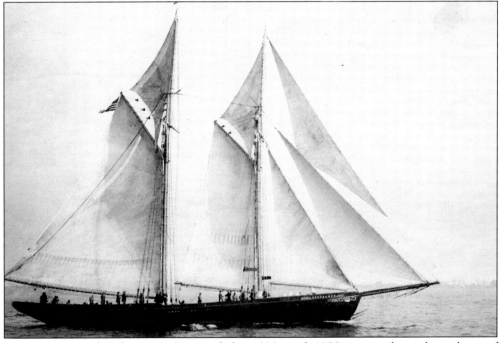

The International Fishermen's Races of the 1920s and 1930s were where the culture of yachtsmen and fishermen collided. The *Esperanto* was the first winner of these contests. (Some would argue it was the only true winner.) In 1920, the editor of the *Halifax Herald* challenged American fishermen to race the best of Nova Scotia's fleet. The 14-year-old *Esperanto* of Gloucester answered the challenge and beat Canadian schooner *Delawana*, returning home to a hero's welcome.

The races inspired a new wave of schooner building, now for national pride more than for fishing. When word got out that the Canadians were constructing a brand-new vessel (the venerable *Bluenose*) to win back the Fishermen's trophy, a Boston syndicate set about building the *Mayflower*. The launch of the *Mayflower* on April 12, 1921, brought the largest crowd ever to Essex. Some estimated that more than 8,000 people came to watch, and cars lined almost every street in town.

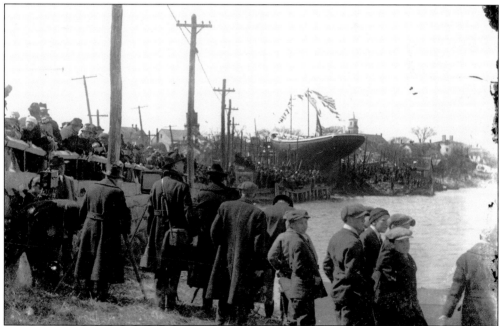

The crowd was galvanized by the intense media coverage that ensued after the victory of the *Esperanto* in Nova Scotia. As the *Bluenose* and the *Mayflower* neared completion, newspapers fanned the flames of the rivalry between the Americans and Canadians.

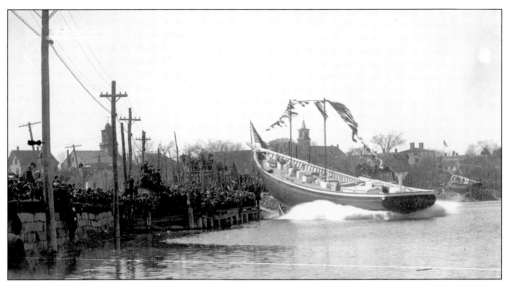

The hopeful defender is launched from the John F. James & Son yard. However, the *Mayflower* was never to get a chance to race the *Bluenose*, as the race committee finally decided that the vessel was not a true fisherman but a schooner yacht and was therefore disqualified. In 1921, the *Bluenose* raced against Gloucester's *Elsie*, a highliner built by A.D. Story in 1910, and brought the trophy back to Nova Scotia.

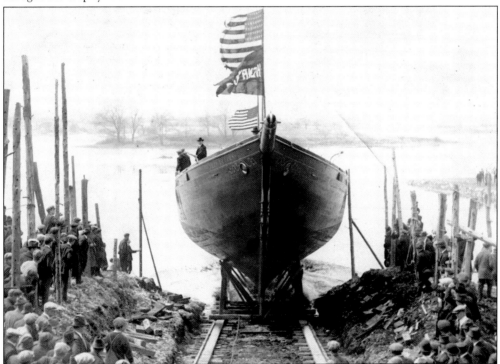

In 1922, Capt. Clayton Morrissey had the *Henry Ford* built at the A.D. Story yard with an eye toward reclaiming the Dennis Trophy. In this view, the *Ford* is launched on April 11. However, the *Ford* also fell victim to the bickering among members of the race committee, and the *Bluenose* retained the trophy.

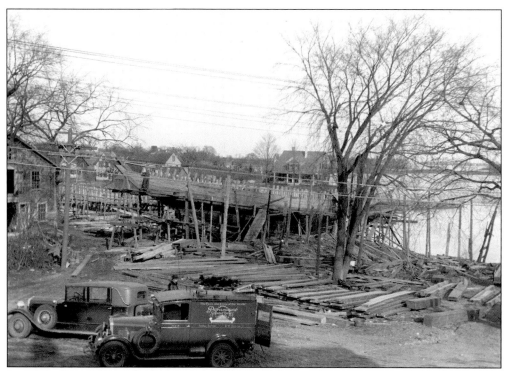

In 1930, Ben Pine made one last attempt to dethrone *Bluenose*. Built with the financial assistance of Gloucester summer resident Louis A. Thebaud and named for his wife, the *Gertrude L. Thebaud* would be the last contender in the International Fishermen's Races. This photograph was taken on February 1, 1930. Once again, the races are the focus attention on the Essex shipyards, as is evidenced by the presence of the Paramount Sound News vehicle in the foreground.

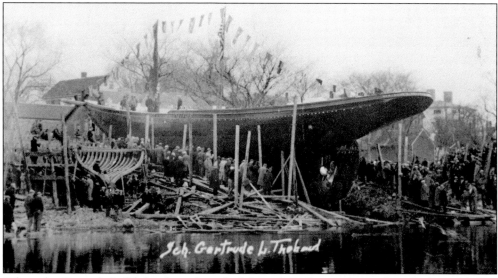

When the *Gertrude L. Thebaud* was launched from A.D. Story's shipyard on St. Patrick's Day 1930, a throng of people was again on hand to wish an American contender well. It is believed to have been the last sailing fisherman launched anywhere in the United States.

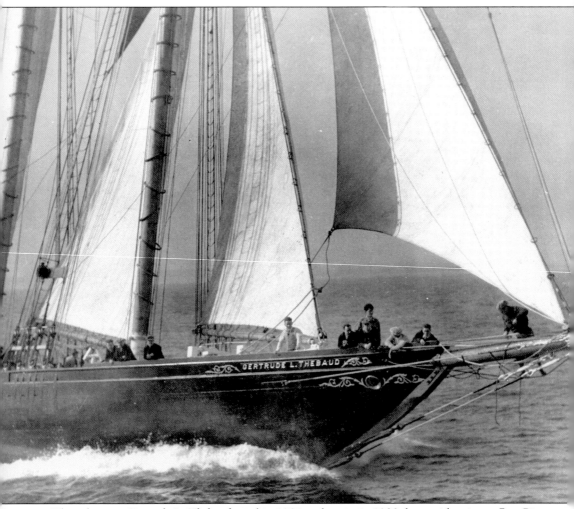

The schooner *Gertrude L. Thebaud* tried in 1931 and again in 1938, but neither it nor Ben Pine ever managed to take the Dennis Trophy from *Bluenose*. (It did win a series in 1930, but the trophy was not at stake.) Of the 4,000 vessels produced in Essex, the *Thebaud* is probably the best remembered. Already an anachronism as it came off the ways in Essex, the *Thebaud* came to represent the tradition of Essex shipbuilding and the Gloucester fisheries. Over its lifetime, it served in many capacities—arctic explorer, ambassador, and a World War II veteran. However, the *Thebaud* is remembered as the last of the sailing fishermen and a symbol of centuries-old craftsmanship and seamanship that quickly disappeared in the first half of the 20th century.

Six

ESSEX VESSELS AT WHARF AND AT WORK

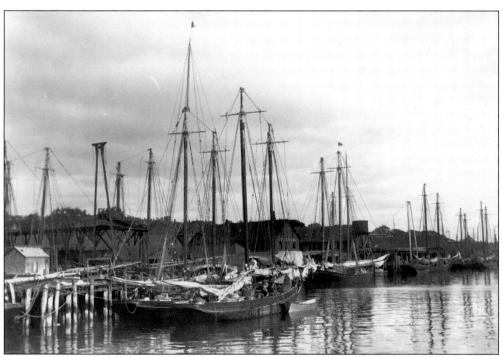

Schooners line the wharves in Gloucester Harbor *c.* 1900. Gloucester was the undisputed capital of the North Atlantic fisheries by the 19th century, the same era when Essex shipbuilding reached its height. Although Gloucester had a shipbuilding tradition of its own, much of it with ties to Essex, the vast majority of Gloucester vessels were built in Essex.

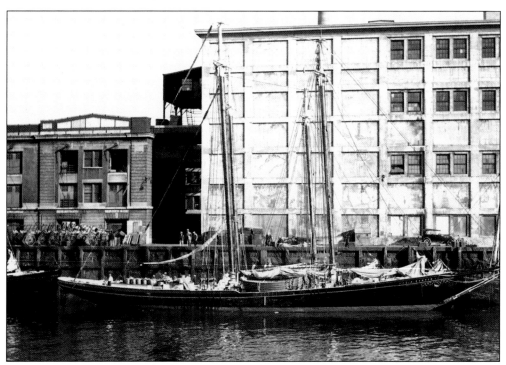

Most customers came to Essex from Gloucester, but many schooners were built for the Boston fisheries. The *L.A. Dunton* was built for Felix Hogan of Somerville and fished out of Boston. In this photograph, the *Dunton* is alongside the Boston Fish Pier soon after being launched in March 1921. The *Dunton* is now a permanent exhibit at Mystic Seaport Museum in Connecticut.

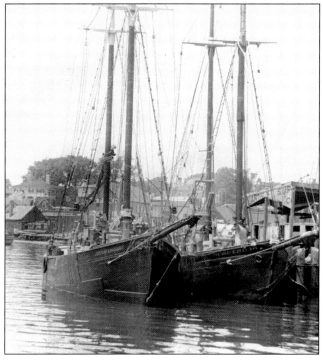

The *Josephine & Margaret* and the *Mary E. D'eon* are tied up outside Ben Pine's Atlantic Supply Company (or Piney's, as it was commonly known). This is approximately where Seven Seas Wharf and the Gloucester House are today.

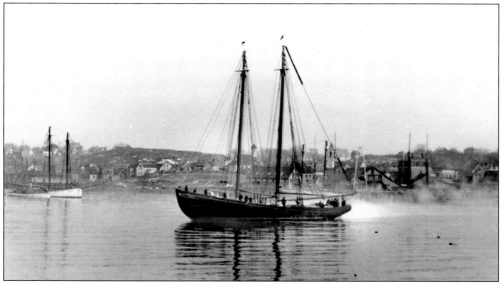

The auxiliary schooner *Knickerbocker* was built in 1912 for the New England Fish Company for halibut fishing off the Northwest coast. The venture turned out to be unprofitable and, by 1915, the *Knickerbocker* was sent back to the East Coast, returning via the brand-new Panama Canal.

This view shows two Essex-built fishing schooners that were subsequently converted to whalers. The *Margarett* (left) was built by James & Tarr in 1889, and the *A.M. Nicholson* was launched from the A.D. Story yard in 1920. Both worked out of New Bedford as whalers. There were 11 known whalers converted from Essex fishing vessels used in the waning years of the East Coast whale fishery.

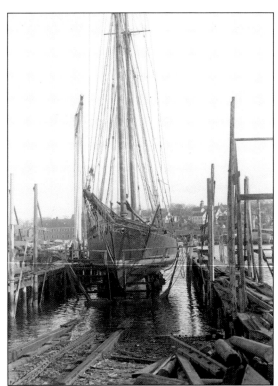

The *Bertha & Pearl* is hauled out for repairs at the Rocky Neck Marine Railways. This was one of three major railways in Gloucester that were kept busy by the constant maintenance needs of wooden vessels.

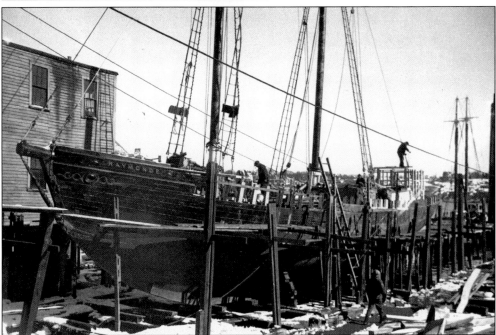

The schooner *Raymonde* was built in Essex by A.D. Story in 1928. Here, the schooner is hauled out in Gloucester, where it is having repairs done to the port-side planking. The vessel is also getting a new pilothouse. This was a period of transition when many schooners were converted from auxiliary-powered sailing craft to fully diesel-powered vessels.

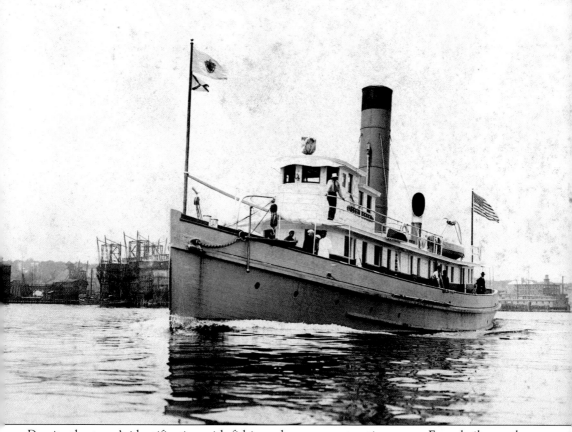

Despite the town's identification with fishing schooner construction, many Essex-built vessels were not involved in fishing. An example is the Massachusetts State Police patrol boat *Lexington* (pictured). A.D. Story was awarded the contract to build it after putting in a slightly higher bid than his competitors because he claimed that he could build the 122-foot steamer in just 120 days. His rivals in the bidding protested that it could not possibly be done that quickly, but A.D. Story prevailed after rallying his acquaintances in the statehouse (Story had been a state legislator), who vouched for his abilities and honesty. The keel was laid on May 20, and the hull was completed and launched only 69 days later, on July 28, 1898, with 2,000 people in attendance. The engine and electrical work were installed in East Boston, and the *Lexington* was ready for work by September 6.

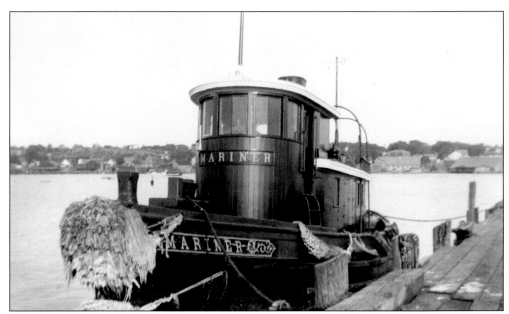

The steam tug *Mariner* was one of the workhorses of Gloucester Harbor. It was launched at the James & Tarr yard in 1907 for the Gloucester Master Mariners Association. The *Mariner* made hundreds of return trips up the Essex River to tow a brand-new schooner to join the fleet in Gloucester.

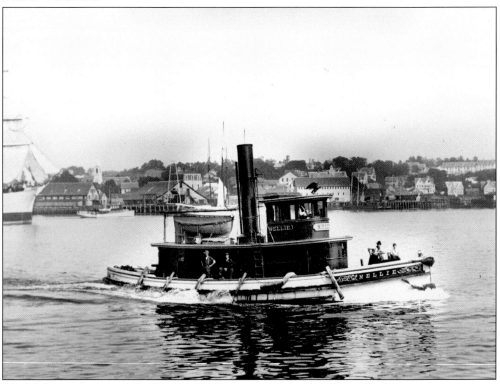

The *Nellie* was built by A.D. Story in 1902. Among the many jobs of the Gloucester tugs was to haul sailing vessels outside the harbor to a point where they would be able to catch the wind.

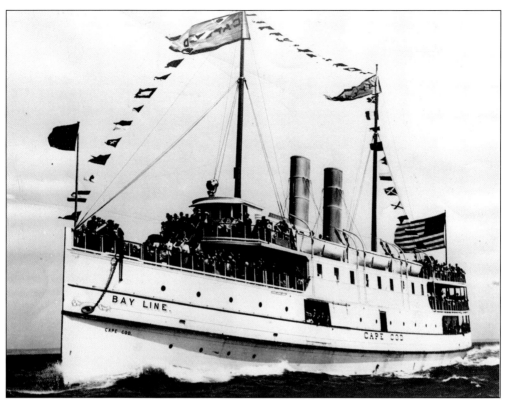

Essex also built passenger steamers. The *Cape Cod* carried travelers from Boston to Provincetown. Launched by A.D. Story in 1900, the *Cape Cod* was 557 gross tons and 165 feet on deck.

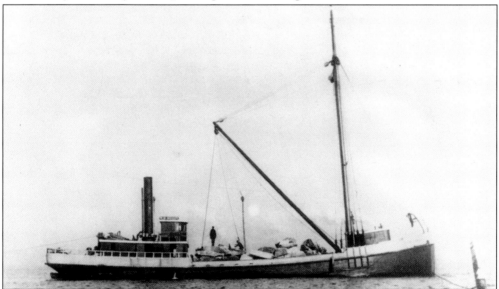

Other types of industries needed Essex-built vessels as well. The *William H. Moody*, built by A.D. Story, was a steam lighter constructed in 1898 for the Pigeon Hill Granite Company in Rockport. Vessels such as this were used to transport massive pieces of granite from the busy quarries in Lanesville and Rockport.

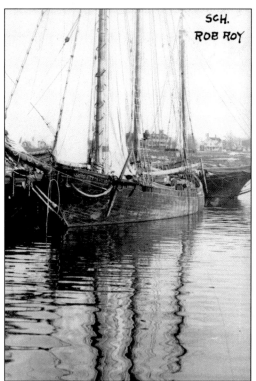

SCH.
ROB ROY

The fishing schooner *Rob Roy* is one of many Gloucester fishing vessels that faced peril during times of war. Built by A.D. Story in 1900, the *Rob Roy* worked in all types of fisheries out of Gloucester until the schooner was sunk on August 13, 1918, by a German U-boat off Seal Island in Nova Scotia. Three other vessels (two from Essex) were lost in the same raid.

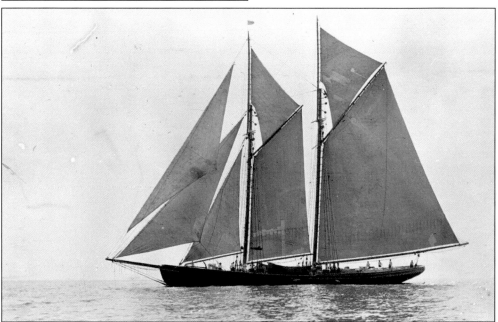

The *A. Piatt Andrew* met the same fate on August 23, 1918, when a seemingly friendly Canadian steam trawler hailed the *Andrew* off Canso, Nova Scotia. The trawler had been captured by the Germans to entrap American fishermen and install bombs on North Atlantic schooners. The Germans boarded the doomed vessel, installed a time bomb, and gave the crew just enough time to take to their dories before the explosion.

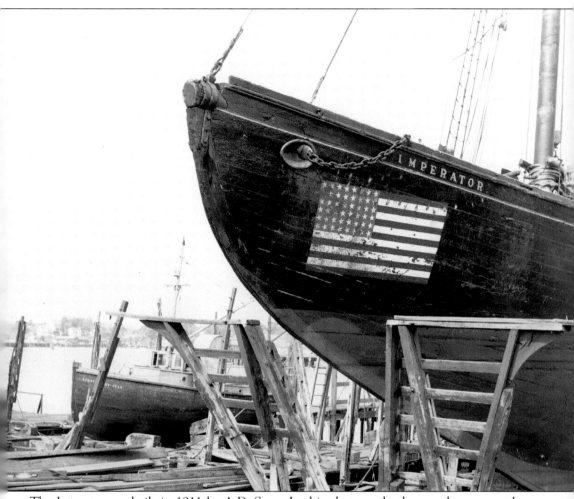

The *Imperator* was built in 1911 by A.D. Story. In this photograph, the vessel appears to be hauled out for repairs during the early years of World War II, before the attack on Pearl Harbor. The American flag is painted on its bow to signal that it was an American (therefore neutral) vessel. After the United States became involved in the war, the U.S. Navy confiscated many Gloucester fishing vessels to employ them as auxiliary coastal patrol boats under the direction of the Coast Guard. These vessels were known as the Corsair Fleet, and they patrolled the region from Bar Harbor, Maine, to Buzzards Bay. Their primary objective was to observe and report any submarine or aircraft activities.

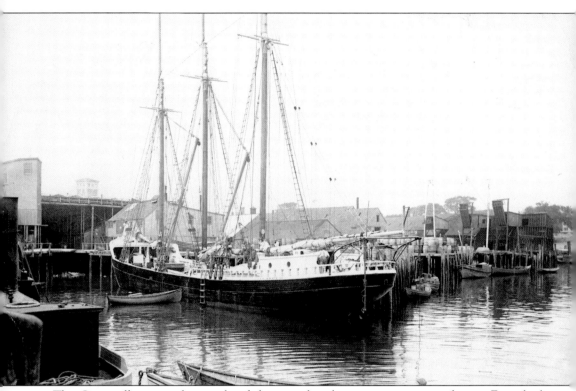

The *Gaspe* offers a good example of the varied and interesting careers of some Essex-built vessels. Constructed by A.D. Story and launched on July 26, 1916, the *Gaspe* was a large three-master built for use in freighting salt herring from Newfoundland to Gloucester. It made at least one trip transporting salt fish to Sweden. In 1922, the vessel was contracted for use in the silent movie *Down to the Sea in Ships,* for which it was fitted out as a whaler, and caught four whales in the process of making the movie. It was next sold to Italian and French interests, taking part in the rumrunning trade in the 1920s. Its last owners were from Newfoundland, where it continued to work as a freighter and rumrunner until its destruction by fire in 1930.

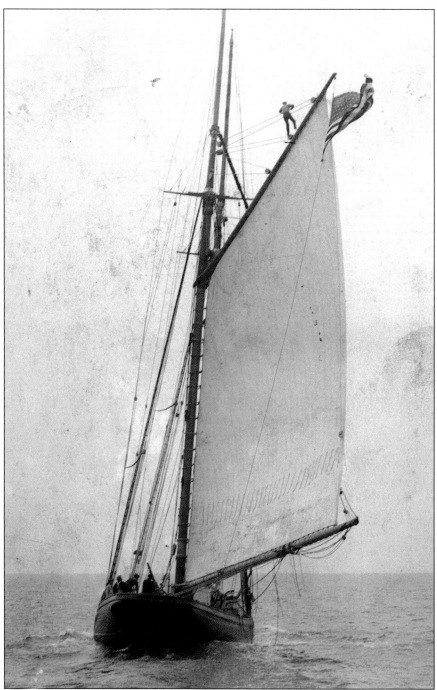

A large knockabout schooner built by James & Tarr in 1907, the *Arethusa* was one of the Cunningham & Thompson fleet. It quickly gained a reputation in Gloucester as an excellent fisherman, usually pulling in a good take for its owners and crew. However, it was *Arethusa*'s career as a rumrunner that earned it the reputation that endures. Capt. Bill McCoy of Florida purchased the *Arethusa* in 1921 and renamed it *Tomaka*. It became known as the best of the rum row fleet, with a cargo capacity of 6,000 cases of liquor.

The schooner *Mary E. O'Hara* was built for the O'Hara Brothers of Boston by A.D. Story in 1922. Five dories are nested on its port side as it heads out for a fishing trip.

Looking back toward the pilothouse and stern of the *Mary E. O'Hara*, this view shows a tub of trawl for dory No. 5 in the foreground. All the dories were numbered and fitted out with identical gear, which was numbered correspondingly.

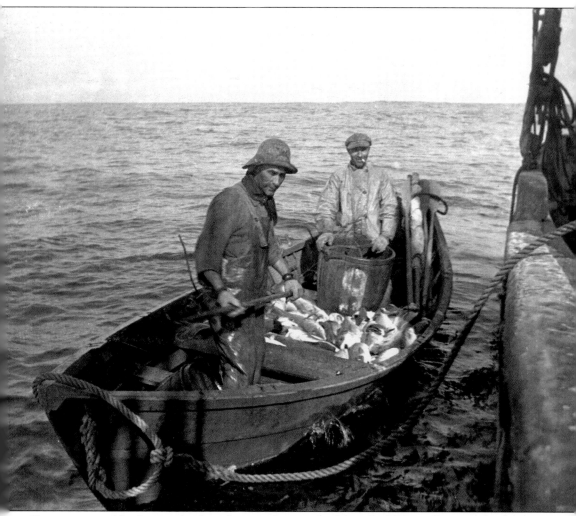

Dory mates on No. 9 are unloading their catch onto the *Mary E. O'Hara*. Dory trawling was one of the most dangerous jobs imaginable. It was not unusual to go astray from the mother ship and be lost forever if a sudden storm or a thick fog came upon them. The crew members of the *O'Hara* met their fate together in January 1941 when the vessel struck a barge coming into port at Boston and sank. The 18 men clung to the rigging for their lives but could not hold on in the frigid winter night.

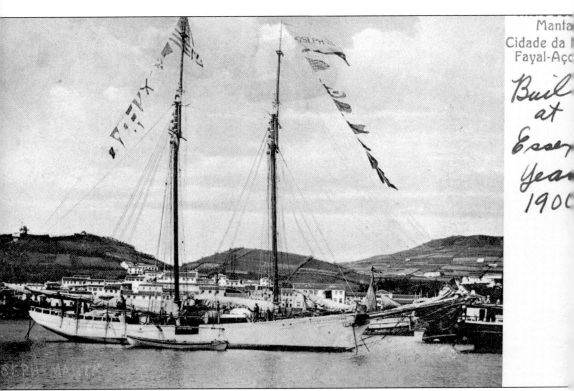

The *Joseph Manta* was built as a whaling schooner by the James & Tarr yard in 1900 for the small remaining whaling fleet in Provincetown. The vessel is pictured in Fayal, Azores. At this late stage in its history, most who were involved with the whale fishery were Portuguese immigrants. Whaling vessels would call on ports in the Azores to get supplies and often to find crew members. Economic hardships on the island and compulsory military service encouraged young men to find work aboard whaling vessels. Whalers would often bring news of other opportunities in the United States, helping facilitate a steady stream of immigrants to Portuguese settlements in Providence, Rhode Island, and in Gloucester, New Bedford, and Provincetown.

The *Etta M. Burns* is tied at a wharf in Gloucester Harbor. It was a Boston-registered vessel built in East Boothbay, Maine, another major shipbuilding community on the North Atlantic coast.

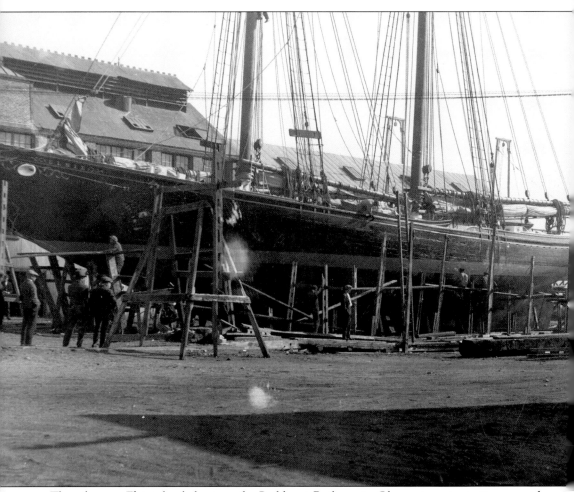

The schooner *Elsie* is hauled out on the Parkhurst Railways in Gloucester prior to its race with the brand-new Canadian schooner *Bluenose*. The *Esperanto*, the original International Fishermen's Race winner in 1920, perished off Sable Island on May 30, 1921. The newly constructed *Mayflower* had been disqualified, so an elimination race was held off Gloucester, in which the seasoned fisherman *Elsie* was victorious.

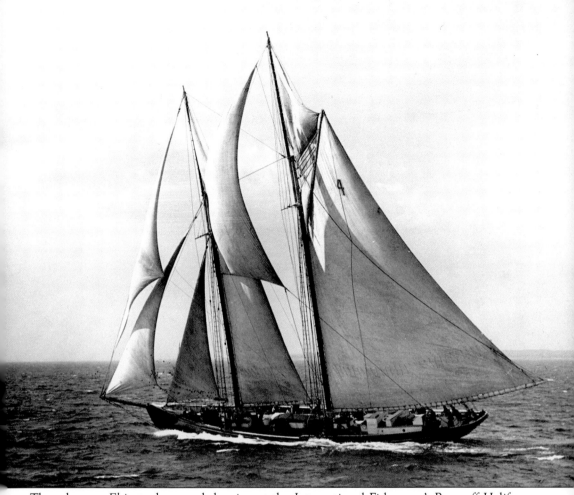

The schooner *Elsie* made a good showing at the International Fishermen's Race off Halifax, Nova Scotia, but its rival *Bluenose* was larger and built specifically to win the prize. *Elsie* was an 11-year-old veteran of the Grand Banks, built not only for speed but with a more practical concern for getting a large amount of fish home to market.

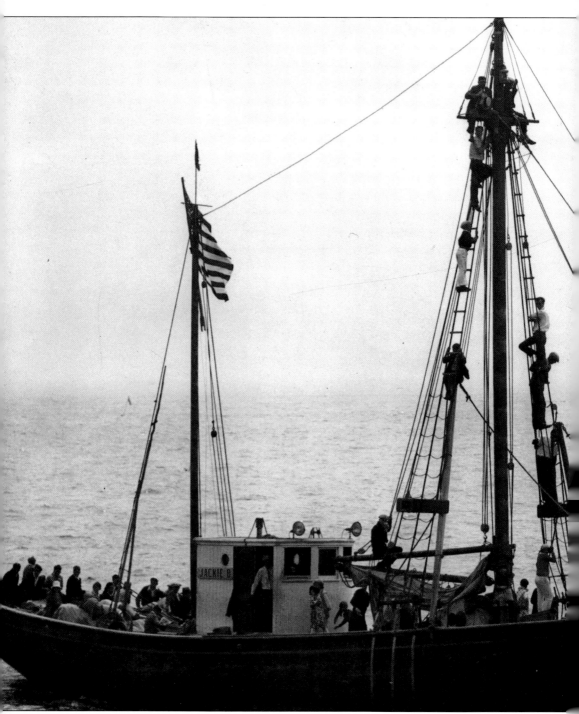

The old and the new are captured together in this photograph, taken during a race off Gloucester in 1929. The dragger *Jackie B.* (foreground) was launched the previous year by the John F. James & Son yard. Its hull form is essentially that of a traditional Essex-built schooner, but it has a 140-horsepower oil screw engine installed and a pilothouse covering its wheel. The spectators are observing what has by this time become rare—a schooner in Gloucester heading out under full

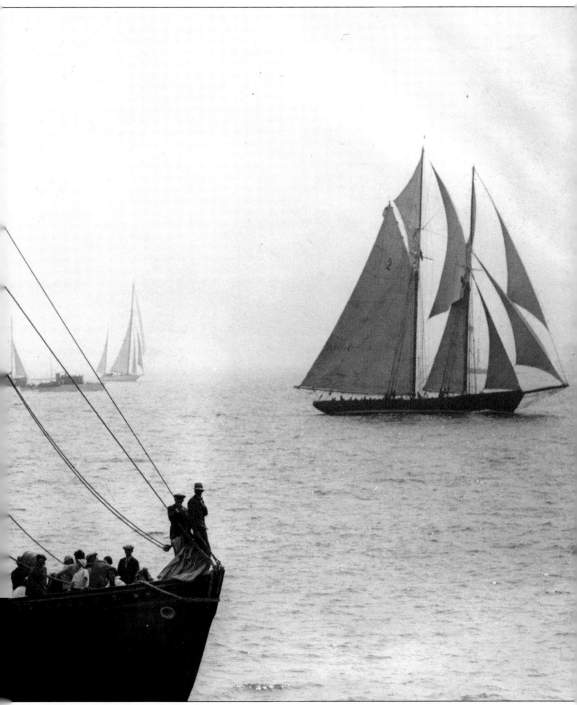

sail. By the 1920s, power prevailed over wind as the method of getting out to the fishing grounds and back to market. Fishermen no longer had to depend on the often fickle weather, and the vessel's speed was consistent and predictable. With so much of the fleet turning to power, a vessel owner would hardly dare compete in the fisheries without it. As the age of sail faded away, sailing races, such as the one pictured here, became increasingly popular.

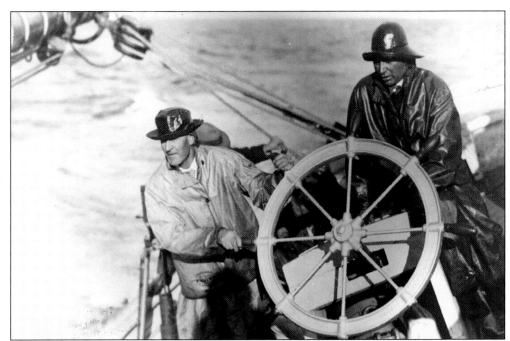

Ben Pine (right), the Gloucester businessman and racing enthusiast, is by the helm of the schooner *Arthur D. Story* in the 1929 race. Photography on board a working schooner was rare, but races afforded photographers a wonderful opportunity to document these vessels under sail.

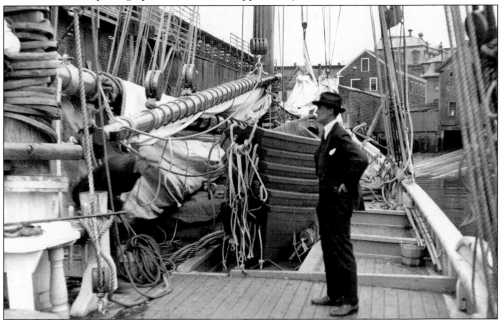

The *Puritan* was a racing schooner that never got to prove its mettle. Built to win the Dennis Trophy back from the Canadians, the *Puritan* boasted the tallest mainmast in the Gloucester fleet. In this view, the schooner is being outfitted for its maiden fishing trip in 1922. On deck stands Frank C. Paine, partner of W. Starling Burgess, the vessel's designer. Speed proved to be *Puritan*'s undoing when, on its third fishing voyage, it overran its course and wrecked on Sable Island.

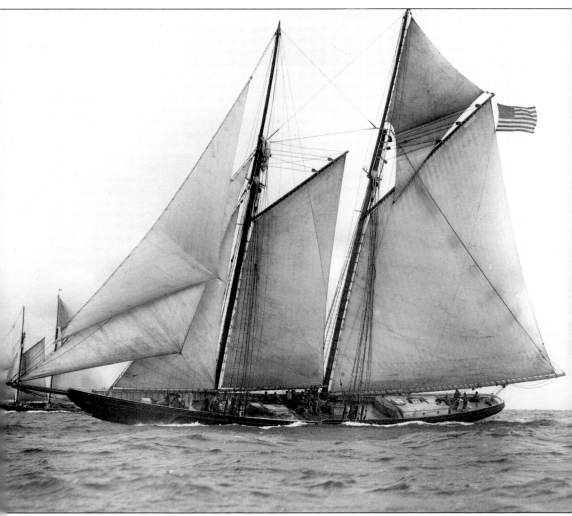

The schooner *Columbia* races the Canadian *Bluenose* in 1923. The series was never finished that year, owing to a battle over the validity of the results of the first race, in which the *Bluenose* finished first but had fouled *Columbia* in the process. Angus Walters was later to admit that *Columbia* was the best he had ever raced against. Ben Pine and *Columbia* did not get chance for a rematch, however. Capping a series of unfortunate incidents in the vessel's short lifetime, the *Columbia* was lost in a gale on August 24, 1927—one of the worst ever to hit the North Atlantic fisheries. It went down with 22 men, most of them Nova Scotians. It was the most lives lost on a single vessel out of Gloucester in the port's long history of such tragedies.

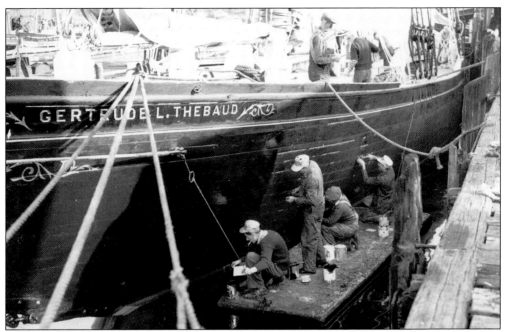

Even the most mundane aspects of vessel maintenance were of interest when gearing up for the International Fishermen's Race. The schooner *Gertrude L. Thebaud* is being readied for a race against the *Bluenose* in 1931.

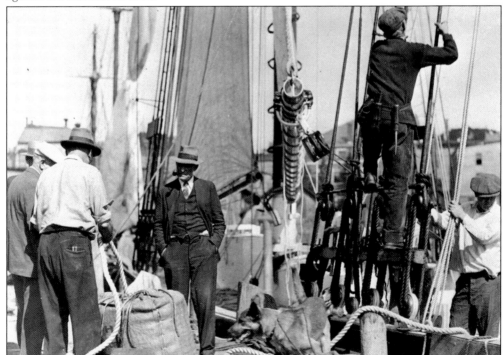

The *Thebaud* is being rerigged for racing. The races between the *Gertrude L. Thebaud* and *Bluenose* in 1931 and 1938 were the last chance for the rival fishing communities in Gloucester and Nova Scotia to show the world—and each other—what they were made of.

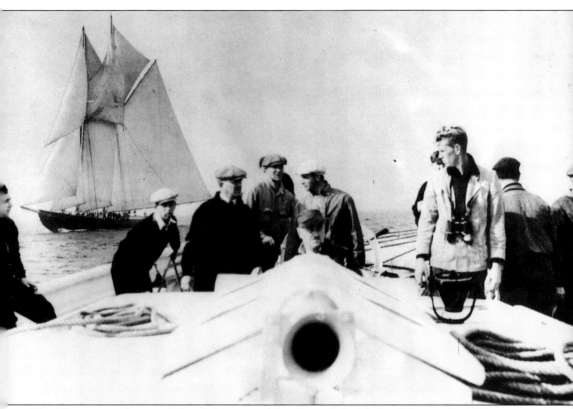

The *Bluenose* can be seen behind the crew of the *Gertrude L. Thebaud* during the 1938 series. Among the crew was the actor Sterling Hayden (with binoculars), who served as navigator. Hayden had a long association with Gloucester and seafaring, and his presence on board helped heighten the interest in what was to be a very close race and a fitting end to a racing era. Also pictured are, from left to right, ? Mitchell (a representative of the *Bluenose*), Stuart Cooney, Marian Cooney, Cecil Moulton (at the wheel), Harry Eustis, Tom Horgan, Elroy Prior, and Everett Jodrey.

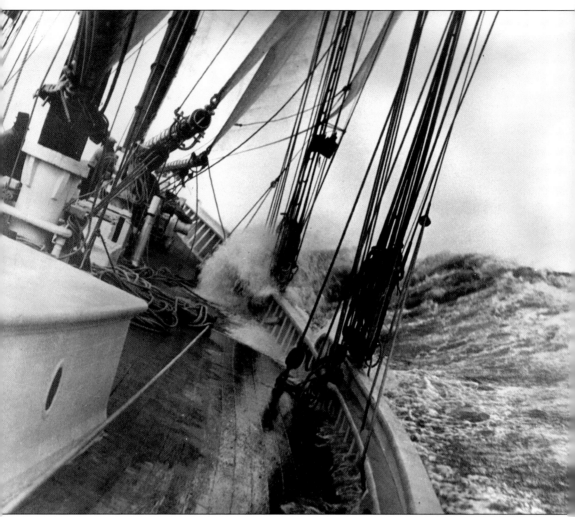

Although the *Thebaud* took the first race in the 1938 series by a winning margin of just under 3 minutes, the *Bluenose* came back to win the next two races by 12 minutes and 6 minutes 39 seconds, respectively. The fourth race went to the *Thebaud* by a 5-minute margin to tie the series. In the fifth and deciding race, the *Bluenose* beat the *Gertrude L. Thebaud* by only 2 minutes 50 seconds, leaving the Dennis Trophy securely in the possession of the Canadians. Although it never beat the *Bluenose* in the International Fishermen's Race, the *Gertrude L. Thebaud* won the hearts of Gloucester and anyone with an appreciation for the maritime traditions that it represented. (George Salter photograph.)

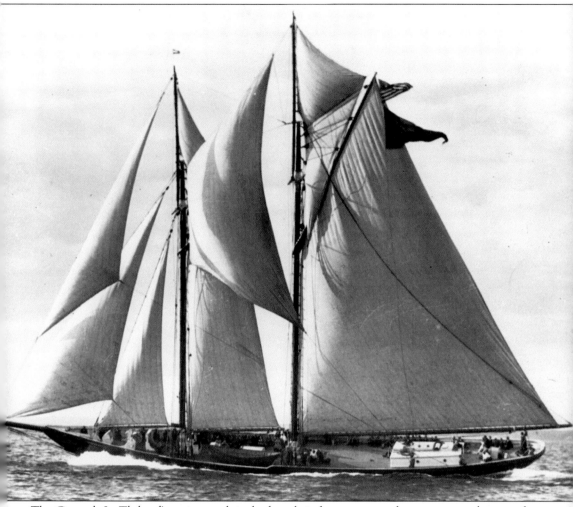

The *Gertrude L. Thebaud*'s racing exploits had made it famous across the country, so the rest of its career was followed with great interest. It eventually went on to serve as the flagship of the Corsair Fleet in World War II. The *Thebaud*'s directive was to patrol the waters off the New England coast and report any possible enemy activity by sea or by air. Its commission with the Coast Guard lasted from 1942 to 1943.

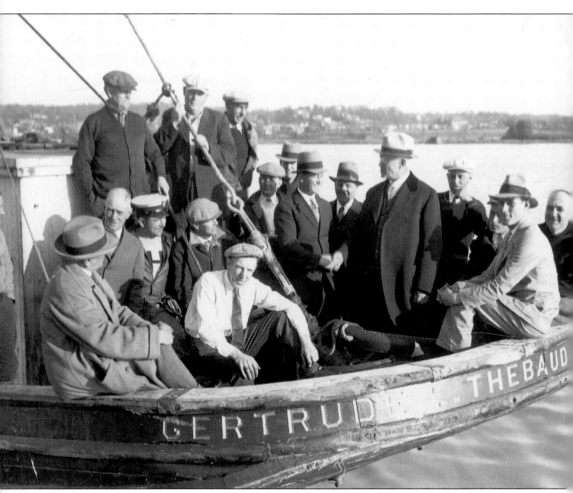

Before its wartime experience, the *Gertrude L. Thebaud* had engaged in a mission of domestic diplomacy. In April 1933, the *Thebaud* served as an ambassador for the fishing industry when it sailed with a delegation of fishermen to Washington to seek aid from the federal government. At the extreme left is Rep. A. Piatt Andrew of Gloucester. In the center, Capt. James Abbott shakes hands with Rep. Allen T. Treadway, also a congressman from Massachusetts. (Associated Press photograph, Essex Shipbuilding Museum Collections.)

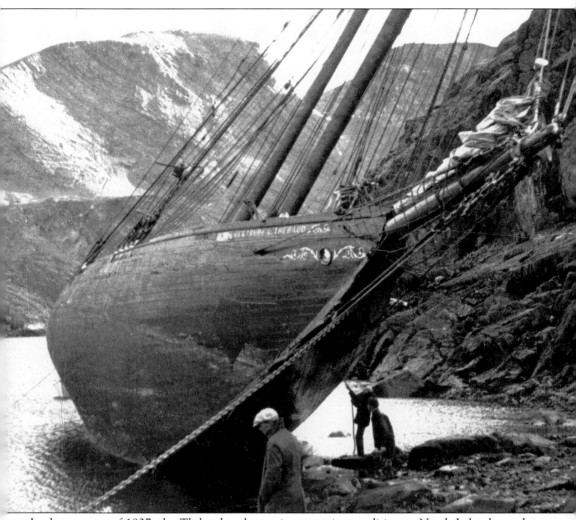

In the summer of 1937, the *Thebaud* took part in an arctic expedition to North Labrador and Baffin Island under the command of Donald B. Macmillan. The scientific team on board included botanists, zoologists, and geologists. Twenty-three students also joined the expedition. In this photograph, the *Thebaud* has grounded on a rock on Baffin Island. When the tide went out, the vessel leaned over against the shore, straining and opening some of its seams. The men could not get a radio signal, so they had to hope the *Thebaud* would float again when the tide came in. Happily, it did, and the expedition continued.

In the 1940s, fishing schooners could not readily compete with the new draggers and trawlers. In 1945, the *Gertrude L. Thebaud* was sold to a New York firm that employed it in the fruit-freighting trade between Florida and the West Indies, where it ultimately met its demise. The *Thebaud* was at anchor in La Guiara, Venezuela, in February 1948 when it was hit by a storm and parted its moorings, smashing into a breakwater. Ironically, its old nemesis *Bluenose* had experienced a similar fate two years earlier when it was wrecked off Haiti while working as a short-haul cargo vessel.

EPILOGUE

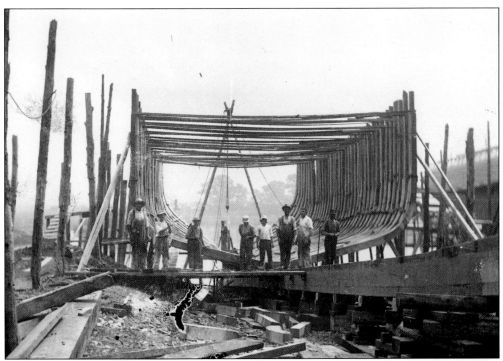

When shipbuilding ceased as a major industry in Essex in the late 1940s, the heritage it created was not lost. Boatbuilding continued on a smaller scale, and the skills were passed along to a handful of people in subsequent generations, but most members of the community looked elsewhere to make a living. However, shipbuilding remained part of the civic consciousness, waiting for a chance to reemerge. That spirit culminated in the opening of the Essex Shipbuilding Museum in the summer of 1976.

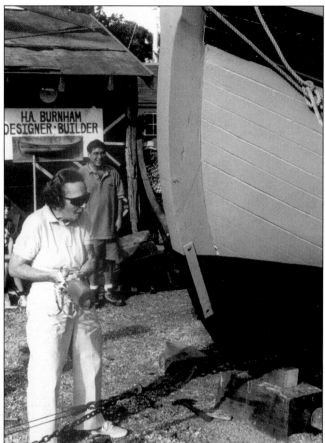

History came full circle in June 1998, when Dana Story's wife, Margaret, christened the Essex Shipbuilding Museum flagship *Lewis H. Story* at the very yard where the Story family built vessels for generations. The *Lewis H. Story,* a Chebacco boat, is a replica of the type of vessel that made Essex famous in the 18th century. It was designed and built by Harold A. Burnham, whose roots go back to the earliest shipbuilders in town. (Courtesy of photographer Lew Joslyn.)

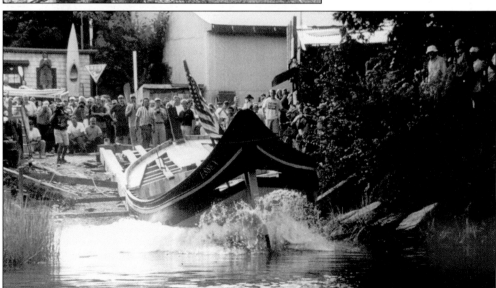

A classic Essex side launching, the first in 50 years, shows what makes Essex a very special place in the maritime world, where centuries of history and present-day ingenuity come together to preserve the past and enrich the future. (Courtesy of photographer Lew Joslyn.)

Ben Pine (left) was adamant that the Dennis Trophy belonged in Gloucester, the port with the best fishermen and the finest vessels. Pine was a waterfront businessman who owned the Atlantic Supply Company and the controlling interest in several fishing vessels. Here, he stands with the captain of the *Bluenose*, Angus Walters, in 1923.

Ben Pine organized the Columbia Associates to finance the construction of the racing fisherman *Columbia*. In this photograph, taken in mid-March 1923, the vessel is planked at the A.D. Story yard. (E.J. Story photograph.)

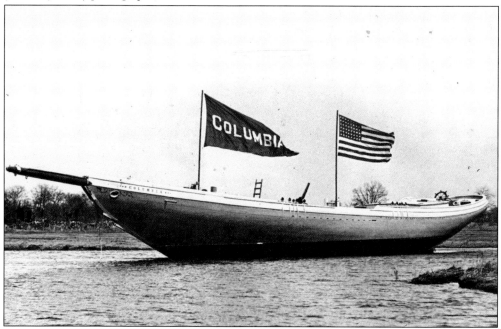

The *Columbia* was Ben Pine's pride and joy. Although the schooner never did best *Bluenose*, its profile was chosen to grace Pine's headstone in the Oak Grove Cemetery in Gloucester. The *Columbia* is pictured on launching day, April 17, 1923.